DARLINGTON
THROUGH TIME
Paul Chrystal

AMBERLEY

Acknowledgements

Thanks to Stan Laundon for permission to use his stunning photographs, taken at Shildon Railway Museum and thereabouts. http://www.stanlaundon.com/

By the same author:

The Last days of Durham Steam (with Stan Laundon) – forthcoming
Hartlepool Through Time
Hartlepool Through The Ages (with Stan Laundon)
Hartlepool History Tour (with Stan Laundon)
Hartlepool: The Postcard Collection (with Stan Laundon)
Redcar, Marske & Saltburn Through Time
York & Its Railways 1839–1950
The Last Days Of Yorkshire Steam – forthcoming
Old Middlesbrough
Secret Middlesbrough
North York Moors Through Time

For a full list of all eighty or so titles please go to www.paulchrystal.com.

First published 2017

Amberley Publishing
The Hill, Stroud, Gloucestershire, GL5 4EP
www.amberley-books.com

Copyright © Paul Chrystal, 2017

The right of Paul Chrystal to be identified as the
Author of this work has been asserted in accordance with
the Copyrights, Designs and Patents Act 1988.

ISBN 978 1 4456 6934 2 (print)
ISBN 978 1 4456 6935 9 (ebook)

British Library Cataloguing in Publication Data.
A catalogue record for this book is available from the
British Library.

Origination by Amberley Publishing.
Printed in Great Britain.

Introduction

Darlington lies in the Tees valley. It is a sizeable market town on the River Skerne, which is a tributary of the River Tees. As the following pages will demonstrate, the town's extensive history is notable for two reasons: it is steeped in Quakerism; and it is world famous for playing a significant part in the world's first passenger rail service – the Stockton–Darlington railway. In the eighteenth century, Daniel Defoe did the town no favours when he wrote that while there was 'good bleaching of linen, so that I have known cloth brought from Scotland to be bleached here', it had 'nothing remarkable but dirt'.

Darlington began as a small village. It first appeared in writing in the early eleventh century when it was called Dearthingtun. Its name was probably originally Deornoth ing tun: Deaornoth was the name of a local man; the word 'ing' meant belonging to; and tun meant farm or hamlet – so it was the place belonging to Deaornoth. For the Normans the name was Derlinton, while during the seventeenth and eighteenth centuries the town was known as Darnton. In time its name changed to Darlington.

In the Middle Ages Darlington belonged to the Bishop of Durham. In the twelfth century the bishop turned part of the settlement into a market town, which attracted locals and inhabitants of outlying farms and villages. The bishop made a lot of money by charging tolls.

Most inhabitants of Darlington at this time were farmers, but there was other industry, not least wool, which was both woven and dyed in Darlington. There was also a leather industry centred on Skinnergate.

The fine and elegant St Cuthbert's owes its origins to Bishop William de Carileph, who in 1084 founded a collegiate church in the town. Darlington was hit by plague in 1543, 1597 and 1605. The town's first Friend's Meeting House was established in Skinnergate in 1678.

In the eighteenth century Darlington gained a reputation for being the manufacturing town of linen, especially towels and tablecloths. The first newspaper in Darlington was published in 1772. The first bank in Darlington opened in 1774. In 1809 a dispensary was founded in Darlington where the poor could obtain free medicines. The first hospital opened in 1864 and on 27 September 1825 the world-famous Stockton–Darlington railway opened.

In 1823 an Act of Parliament formed a body of men to clean the streets of Darlington and light them with oil lamps. They could also appoint nightwatchmen. From 1830 Darlington enjoyed gas lighting. A water company was formed in 1846 to supply piped water. In the 1850s a network of sewers came on stream.

By the nineteenth century the influential Quaker Pease family started to have a beneficial influence on the city. In 1875 the statue of Joseph Pease (1797–1872) was erected. Joseph Pease, railway pioneer (1799–1872), was the first Quaker Member of Parliament for South Durham. Like most Quakers back then, he always refused to remove his hat, even when he entered the House of Commons. South Park was laid out in 1877 and from 1880 horse-drawn trams rattled down the streets. Darlington's first public library opened in 1885 and Central Station was built in 1887.

By 1900 Darlington had a population of 50,000. The linen industry declined but was replaced by engineering and bridge building; iron foundries were constructed.

Electricity was first generated in Darlington in 1900. Horse-drawn trams were replaced by the electric variety in 1903. These in turn were superseded by buses in 1926. The curtains went back in Darlington's first cinema in 1911.

The Queen Street Centre opened in 1969 and Darlington's new council offices went up in 1970. Darlington Sixth Form College was inaugurated in 1970 and the Railway Museum opened in 1975. Northgate House was built in 1976 and the Arts Centre opened in 1982. The Dolphin Centre was opened by Roger Bannister in 1983. The Cornmill Shopping Centre opened its many doors in 1992. Today the population of Darlington is 106,000.

All of this and more is explored in *Darlington Through Time* in an incisive and informative text with two hundred or so illustrations, old and new – charting the rich history of this vibrant Durham town.

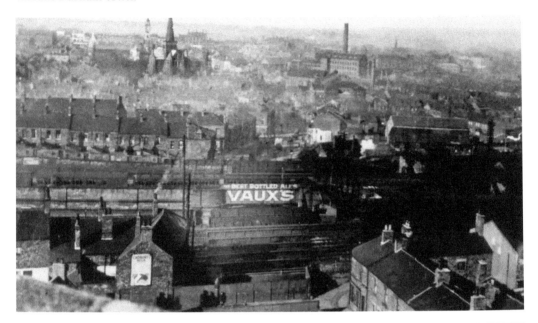

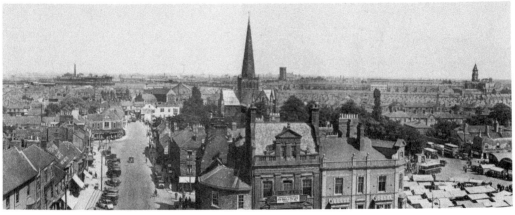

Two aerial views of Darlington – one industrial, the other less so. The lower image is taken from the old Town Hall looking east towards Tubwell Row, with the market lower right.

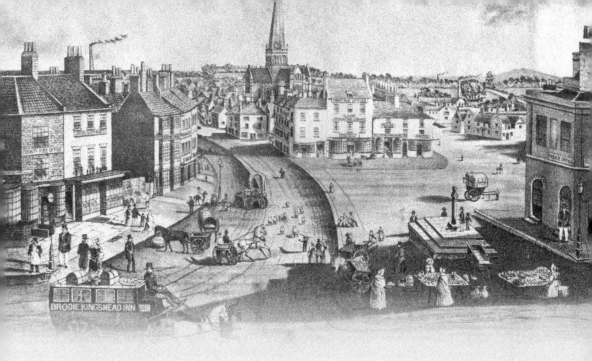

CHAPTER 1

Early Days

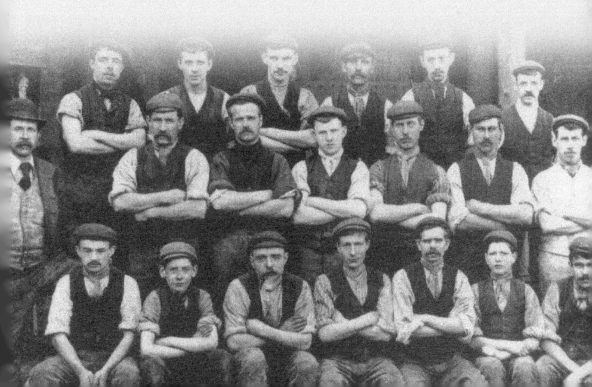

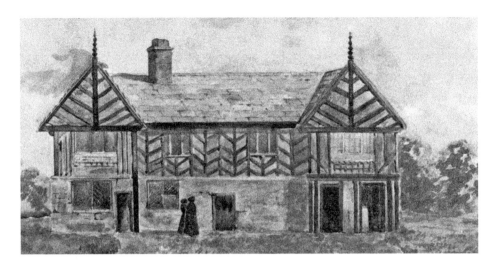

The Deanery and Pease House

Our first records of Darlington was as an Anglo-Saxon settlement. It was then overrun by the Danes, for which evidence survives in the many street names of Danish origin. From very early days Darlington's market has been the focus of the town and remains so today. The image on page 5 shows Market Place in 1843 with the town hall on the right (housing the police office and the dispensary). Quaker Kitching's Foundry is on the left, opened in 1790 and later it manufactured nails for the railways. The later railway foundry built locomotives – Whessoe grew from this. The lower picture shows Kitching staff. On this page we can see the Deanery in around 1766, on the corner of Horsemarket and Feethams. The modern picture is of Edward Pease's house in Houndgate – the fountain was originally outside the old town hall at the junction of Tubwell Row and Prebend Row, then moved to Green Park before it settled in the garden of Pease House.

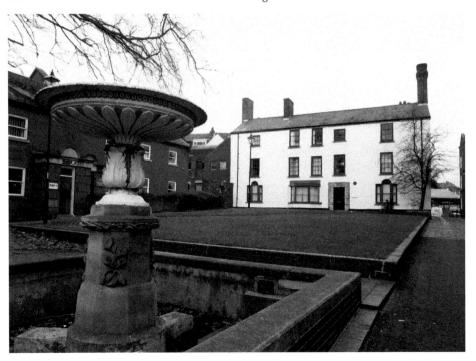

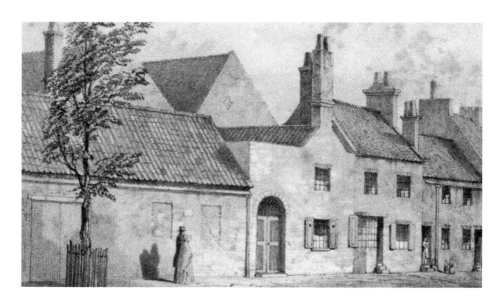

Quaker Darlington

The nineteenth century was the age of the powerful and influential Quaker families in Darlington. The Pease and Backhouse families were preeminent as employers and philanthropists. Darlington's famous landmark, the clock tower, symbolises this: it was gifted to the town by Joseph Pease in 1864. The Darlington Mechanics Institute was opened in 1854 by Elizabeth Pease Nichol, who paid for most of its construction. 91-acre South Park was redeveloped in 1853, financed by the Backhouse family. We have Alfred Waterhouse to thank not just for the Natural History Museum in London and Manchester Town Hall, but also the Grade II-listed Victorian Market Hall in 1860, and the Backhouse's Bank building, now a Barclays, in 1864. George Gordon Hoskin's work is visible throughout the town, not least The King's Hotel and the Darlington Free Library, funded by Edward Pease and opened in 1884. The top picture shows the Friend's Meeting House in Skinnergate in 1838. The lower picture is of Bondgate.

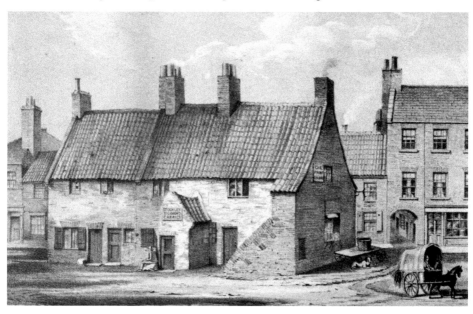

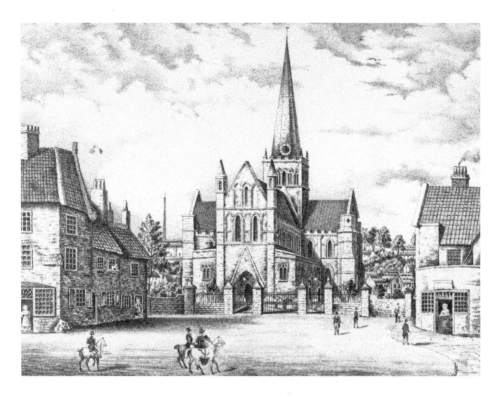

St Andrews and a Castrated Bull

The 1183 Grade I-listed St Cuthbert's Church is one of England's most important early English churches. Darlington's oldest church, however, is St Andrew's Church, which was built around 1125. The picture shows St Cuthbert's around 1843 – the Lady of the North and Darlington's oldest surviving building. The Durham Ox was a castrated bull famous in the early nineteenth century for his prodigious shape, size and weight. He was an early example of the Shorthorn breed of cattle, and helped define the breed. When exhibited at Darlington in 1799, he was the Ketton Ox. The etching of the Durham Ox is by John Boultbee (1753–1812).

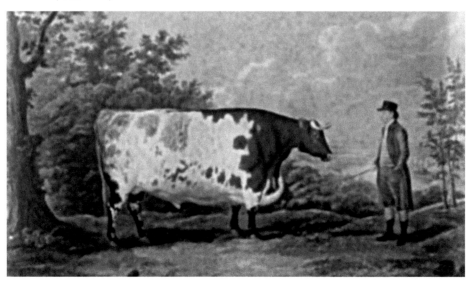

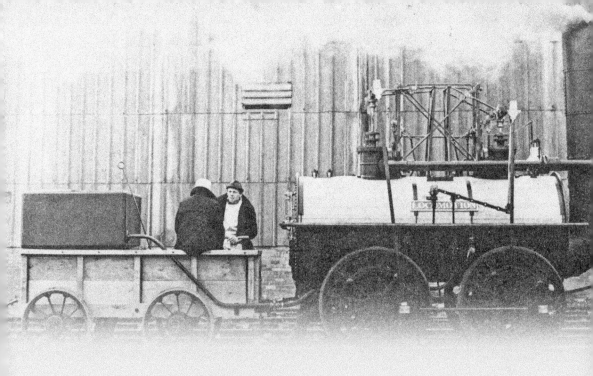

CHAPTER 2

Industry I

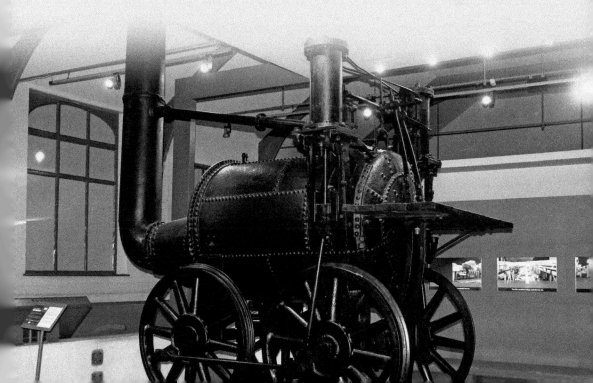

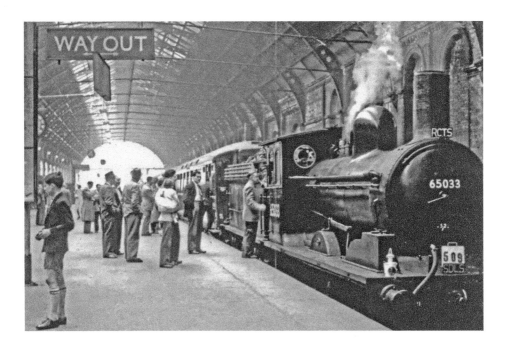

Trains

Darlington is synonymous with the birth of passenger railways in the British Isles. This momentous event is celebrated at the Darlington Railway Centre and Museum. The world's first passenger rail journey was between Shildon and Stockton-on-Tees, with *Locomotion* passing through Darlington, on the Stockton & Darlington Railway in 1825. *Teddy* the tiny tank engine is a popular exhibit at the Shildon Museum. Peckett 0-4-0st No. 201. © Stan Laundon. The upper picture shows Bank Top Station.

The images on page 9 show a restored *Locomotion* and *Sans Pareil*, the latter exhibited at the Shildon Railway Museum. © Stan Laundon. The fully operational full-size replica of *Locomotion No. 1* is owned by the Locomotion Trust.

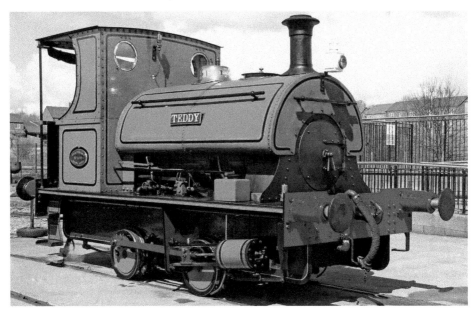

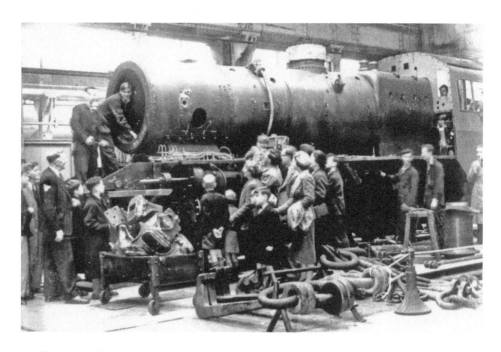

Darlington Railway Works

The top image shows schoolboys swarming all over a steam locomotive, in for repairs in the 1960s. The lower image shows 61413 rusting away in a Darlington siding. She was built at Darlington in 1920, first worked out of York North shed, was taken out of service in 1961 and cut up at Darlington Works, North Road, in 1963. Railway manufacturing sprang up at the Hopetown Carriage Works, established in 1853, supplying carriages and locomotives to the Stockton & Darlington Railway. As we have seen, William and Alfred Kitching was another engineering company also building locomotives in nineteenth-century Darlington.

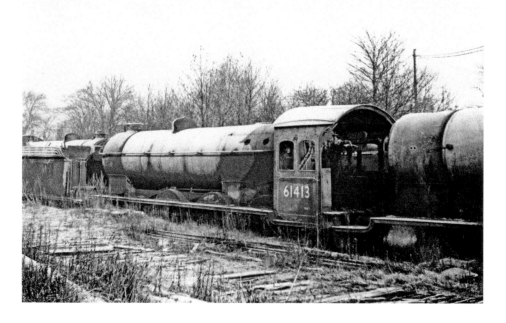

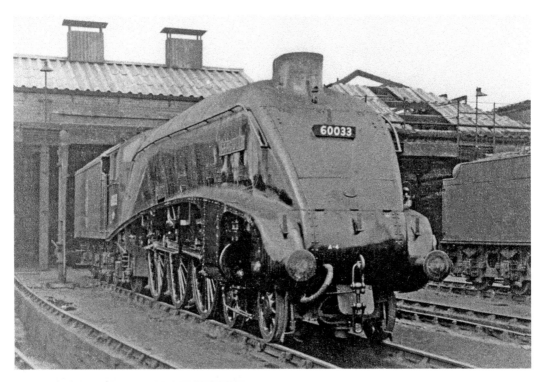

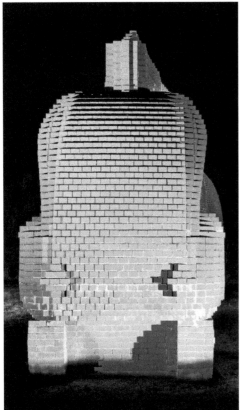

Train

A stunning commemoration of the town's railway heritage is David Mach's 1997 work *Train*, which is on the A66 near to the original Stockton–Darlington railway. The life-size brick sculpture of a steaming A4 locomotive looming out from a tunnel is made from 185,000 'Accrington Nori' bricks and cost £760,000 (© Stan Laundon). The older photograph is of 60033 *Seagull* at Darlington sheds, one of thirty-five LNER Class A4 Gresley Pacific steam locomotives built at Doncaster. It entered service on 28 June 1938.

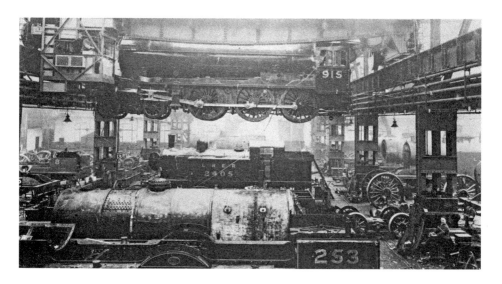

Railway Darlington

The town developed to have four significant works. The largest of these works was the main line Darlington Works, whose main works were known as the North Road Shops, which opened in 1863 and closed in 1966 after 103 years. Another was Robert Stephenson & Co. (colloquially known as 'Stivvies'), who moved to Darlington from Newcastle upon Tyne in 1902, became Robert Stephensons & Hawthorns in 1937, were absorbed by English Electric around 1960, and closed in 1964. The third was Faverdale Wagon Works, established in 1923 and closed in 1962, which in the 1950s was a UK pioneer in the application of mass-production techniques to the manufacture of railway goods wagons. Kitching's was the fourth. The upper photo shows work in progress at the North Road Locomotive Works. Beneath, 60010 *Dominion of Canada* is being restored at Shildon. She was withdrawn at Darlington shed on 29 May 1965 and on 5 July 1965 was marked as 'for sale to be scrapped'.

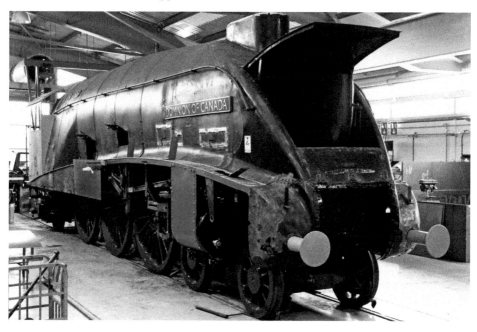

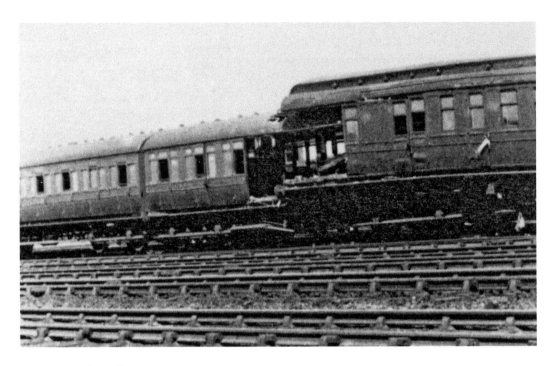

Carnage on the Railways

The upper image shows what happened when a Newcastle freight train smashed into the back of a goods train just outside Bank Top Station on 15 November 1910: the driver and fireman of the freight train were killed. In the lower picture, on 27 June 1928 at Bank Top Station, an excursion train from Scarborough to Newcastle collided with a shunter. Of the twenty-five people killed, fourteen were members of a woman's group from Hetton-le-Hole.

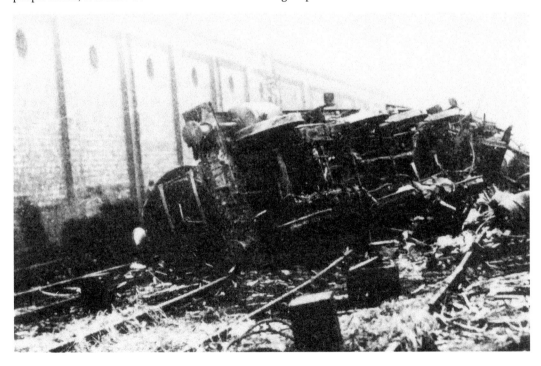

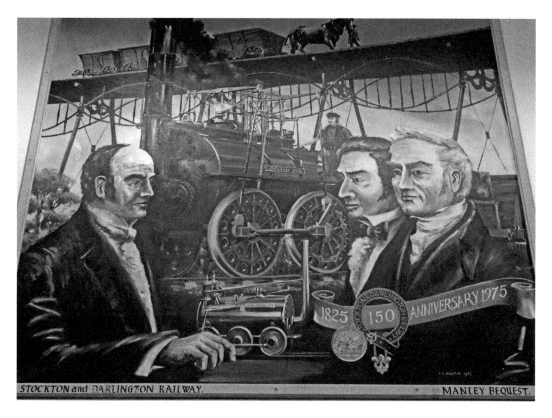

STOCKTON and DARLINGTON RAILWAY. MANLEY BEQUEST.

More Carnage

More carnage in the lower picture, caught on this morbid card showing a double-headed freight train derailed en route from Winston to Darlington on 24 October 1905. The upper image shows the architects of the Stockton & Darlington Railway in a painting commissioned for the 150th anniversary in 1975, now hanging in Darlington Library.

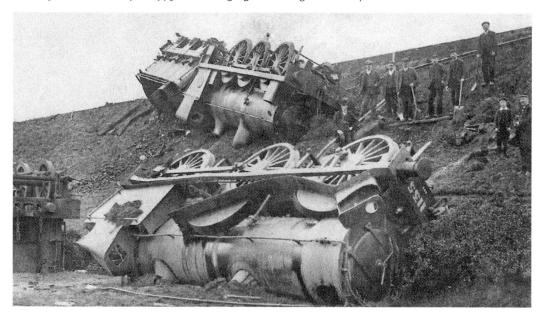

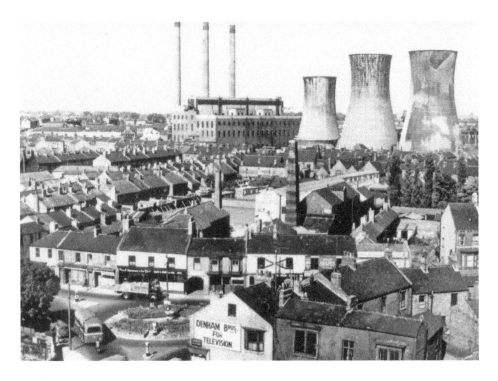

Cooling Towers

Cooling towers at Haughton Road erected for two coal-fired power stations in 1900 alongside the East Coast Main Line to facilitate the delivery of coal. A new station opened in May 1940 with three large, hyperboloid reinforced-concrete cooling towers and three brick-built chimneys. The cooling towers were demolished in 1979; the chimneys were manually disassembled in 1978.

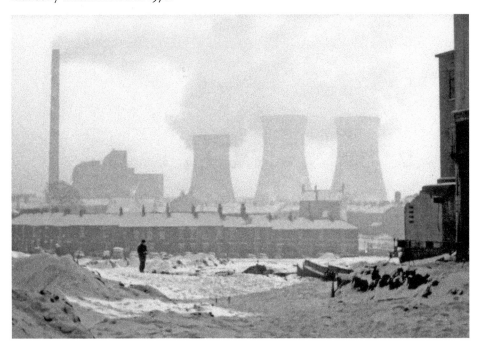

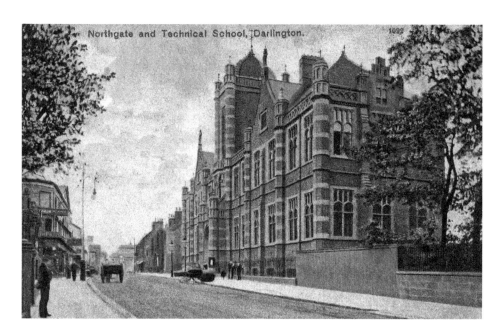

Darlington Technical College

Engineering is still a major industry and employer in Darlington. Cummins, the engineers, has major premises in Darlington, and the industrial headquarters of AMEC are here. The Darlington Forge Co., which closed in 1967, operated from here. Whessoe started in Darlington. Darlington Technical College opened in Northgate in 1897 to train many of the apprentices and staff in Darlington's factories and businesses. The building is now owned by the council.

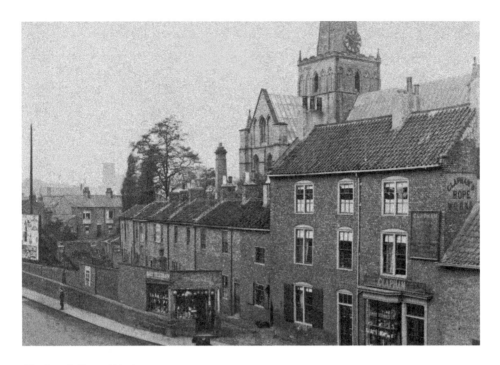

Clapham's Rope Works

Clapham's were in Tubwell Row. This photo was taken before 1894 when the building was demolished. Ropery Yard was on the site of the Darlington Museum. Darlington is particularly noted for its bridge building, and Darlington bridges can be found spanning the River Nile and the River Amazon. Cleveland Bridge & Engineering Co. still has its headquarters in the town, in Yarm Road. The firm built the Tyne Bridge, Middlesbrough Transporter Bridge, the Victoria Falls Bridge and the Humber Bridge, as well as the Sydney Harbour Bridge. The modern photo shows the Transporter Bridge in Middlesbrough today. (© Stan Laundon)

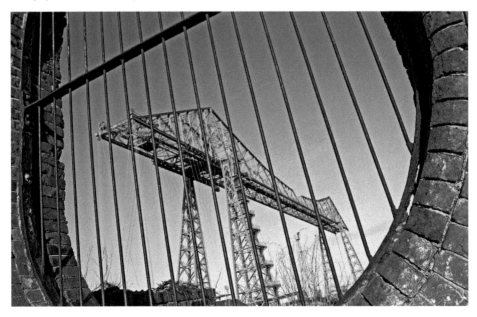

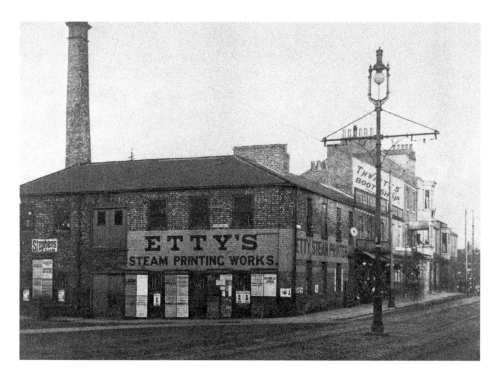

Etty's Printing Works

The upper picture shows Etty's Steam Printing Works in Crown Street. It was demolished in 1906 and the site was taken by the gas showrooms. Beneath that is a shot of the old Darlington Bottling and Mineral Water Co. Ltd factory, established in Gladstone Street in 1889. BT Group have a major presence in Darlington: the town is one of the locations in England that have had subterranean BT fibre-optic cables installed underground as part of BT Infinity superfast broadband rollout project.

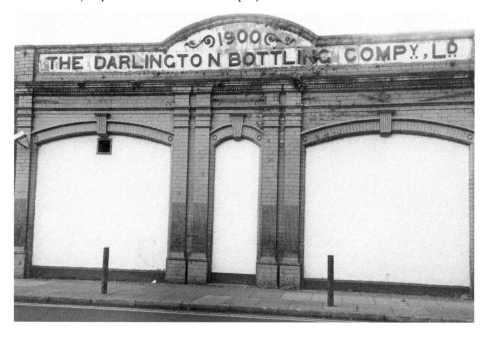

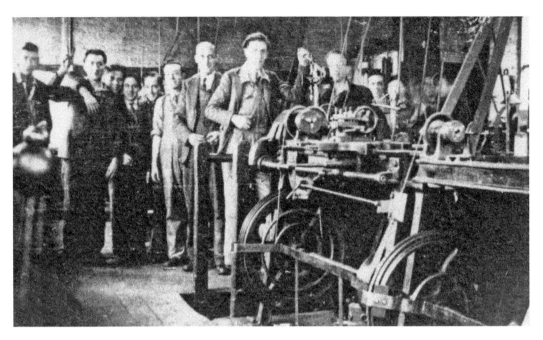

Edgar Cox-Walker and the Telephone

Apprentices and craftsmen in their Houndgate electrical engineering factory on the corner with Feethams. Edgar Cox-Walker was founded in 1880 and was a pioneer of the telephone, installing a system for Darlington Corporation in 1881, five years after Alexander Bell took out his patent.

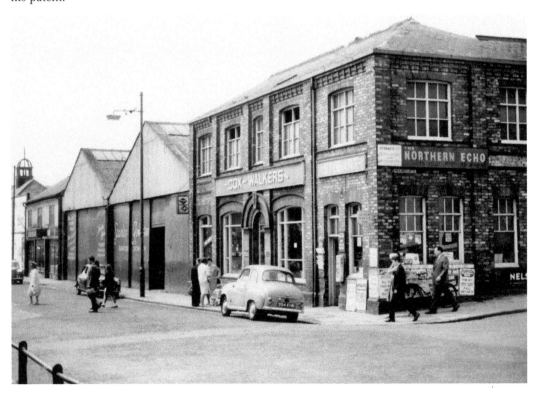

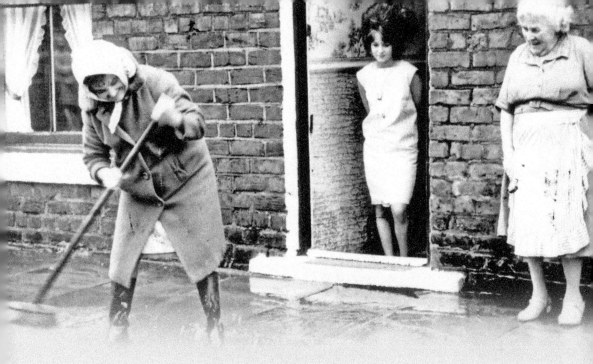

CHAPTER 3

Darlington People

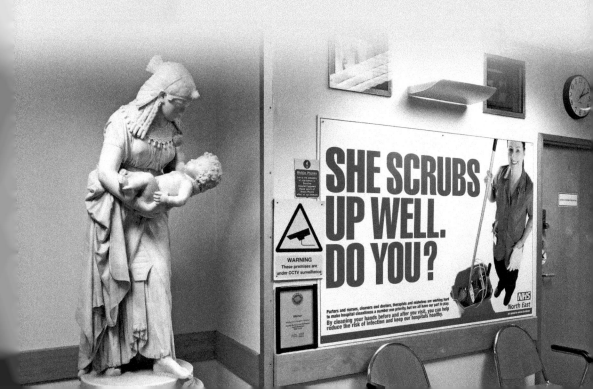

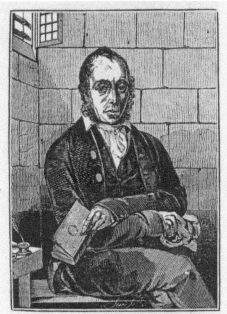

JONATHAN MARTIN
THE LUNATIC,
Who set York Minster on Fire, February 2, 1829.
From a Painting by Mr. E. Lindley, taken in Prison, by permission of the Magistrates.
March 31, 1829. York :—Published by H. Bellerby, 12, Stonegate.

Jonathan Martin, Cathedral Arsonist
The first of three (so far) major fires at York Minster was in 1829 when the arsonist Jonathan Martin destroyed the archbishop's throne, the pulpit, the organ and the choir, and damaged the choir screen and some windows; after this the dean and chapter prudently resolved to reinstate the lapsed post of nightwatchman. Martin was protesting against the worldliness of the church. The church he was hoping to destroy is in the lower picture.

The photo on page 21 shows some carefully observed flood cleaning up in Mount Street. Beneath that is the beautiful *Pharaoh's Daughter* by Giovanni Battista Lombardi (*see* page 52), which graces the sixth floor of Darlington Memorial Hospital. The siting of the poster is surely no accident.

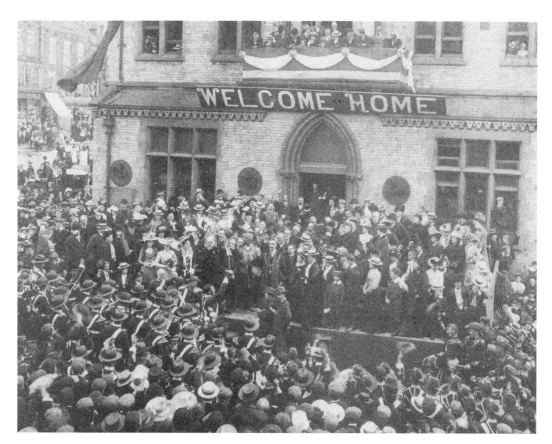

Welcome Home Darlington Volunteers
The mayor welcomes back home the Volunteers from South Africa on 1 June 1901 at the old town hall. During the Boer War volunteers from the five Durham battalions provided four companies of 116 of all ranks, for one year's service to reinforce the army in South Africa. The 3rd battalion, with 826 officers and men, served in the Cape Colony and the Orange Free State, and garrisoned Dewetsdorp for six months. It lost twenty-nine officers and men. The memorial is shown in the lower picture.

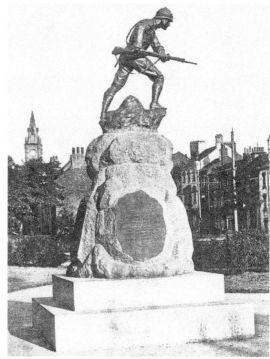

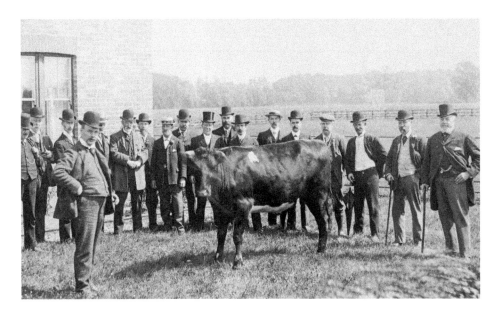

Edward VII 1902 and the Bull

The ox roasting committee preside over the doomed bull, sacrificed for the coronation. Roasting took place in the marketplace. Prizes were awarded for the best-dressed shops and houses, children paraded and there was a huge bonfire and a coronation feast. The ox took fifteen hours to roast, and was enjoyed by the 2,000 Darlington people who ate the sandwiches. The view of the roast from an upstairs windows of the Bull's Head Hotel was so impressive that the scenes were painted on the walls. Over the years, they inevitably got papered over but were rediscovered just before the pub closed in 1956. The new photograph shows a bull, similarly doomed perhaps, at Darlington Farmers Auction Mart Co.

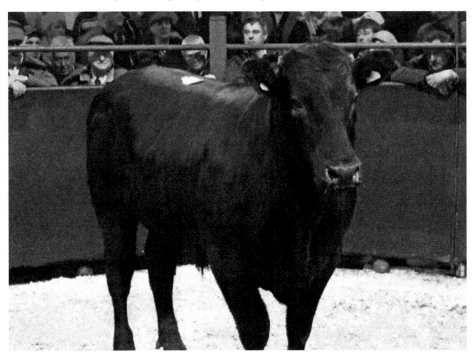

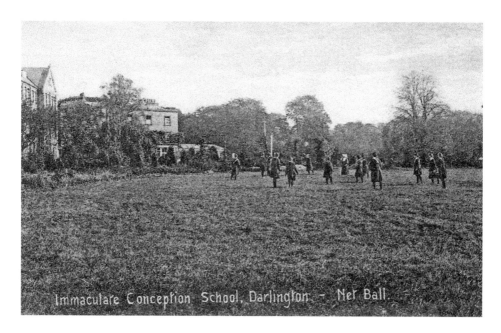

Netball and the Immaculate Conception

Note the nun refereeing. Immaculate Conception Convent Grammar School, founded in 1904, joined St Mary's in 1974 to form Carmel School. The building, originally known as 'Southend', was built in 1804 by Quaker Edward Backhouse, founder of Barclays, who sold it to Joseph Pease. The house was later bought by the sisters of Charity of Saint Vincent de Paul, who made it into a school. The lower picture shows the Chinese Imperial Commissioners on their visit to Rise Carr Rolling Mills in April 1906. Rise Carr was a puddle mill where steel bars were rerolled. The visit took place while the mills were producing iron bars for the British Admiralty.

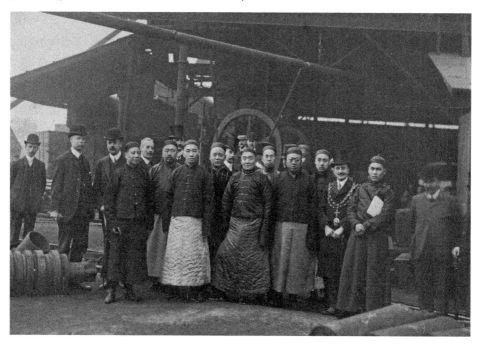

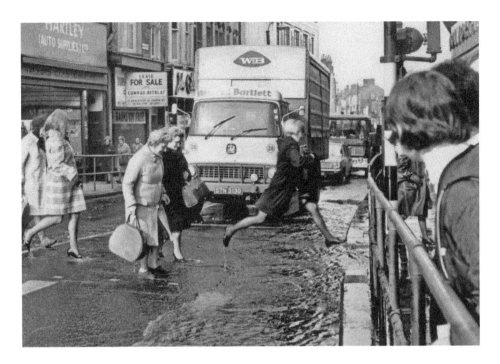

Queen Street Floods

That intrepid woman had no trouble negotiating the flood water in Queen Street; one wonders, however, how the two old ladies fared. The modern photo shows the entrance to the Queen Street Shopping Centre.

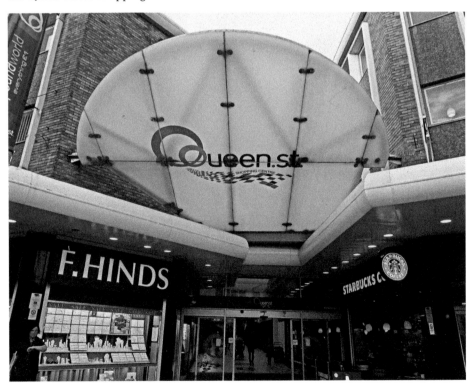

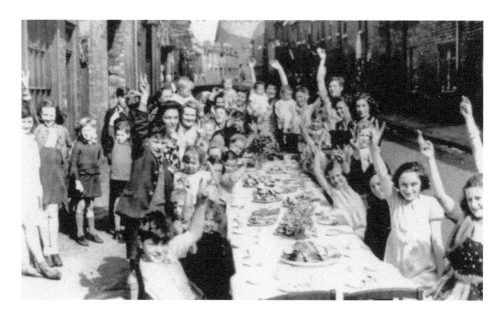

Hands up for VE Day

VE celebrations in Brunswick Street with a cooling tower looming in the background. In Tubwell Row a football match is held using beacons from a pedestrian crossing – as floodlighting, not footballs. The new picture shows military personnel on guard outside Kitt Pongo and the Hogman Military Bunker in Northgate.

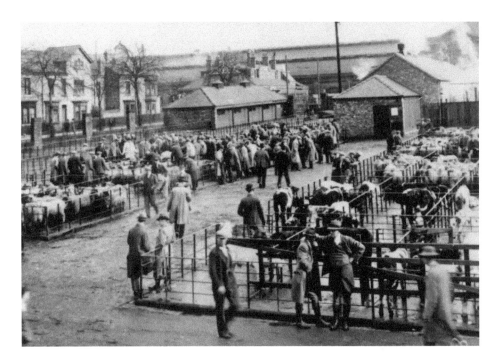

Darlington Cattle Market

A fine shot of the busy cattle market in the 1930s. Today the market is operated by the Darlington Farmers Auction Mart Co. Ltd, established in 1887, and is at Clifton Road, close to Bank Top Station. This is how the market was described in the eighteenth century: 'On Cow Monday, the beasts of the field have it all their own way in Darlington, and they gorm about the footpaths and pavements of High Row as if they were in their own green pastures.'

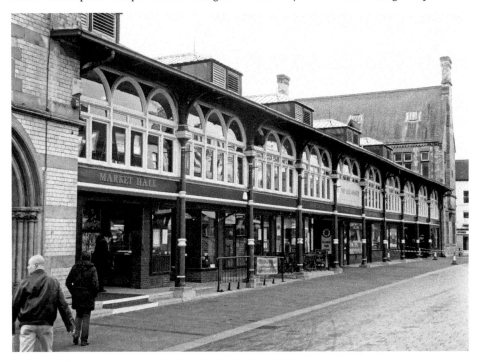

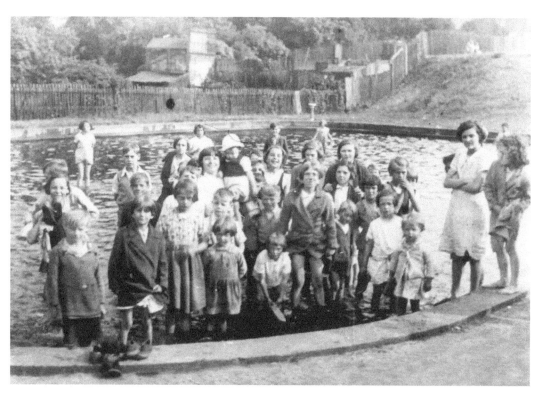

Drury Street Paddling Pool

Judging by some of the glum expressions, the water may not have been quite as warm as it might have been that day in 1935. The Cockerbeck Valley Park, known as the Denes today, opened from 1923. A paddling pool containing 12 inches of water opened on 20 March 1926 in the dene at the foot of Drury Street, soon to be followed by a sandpit. The modern image is one of the paintings in the Tell Her Story exhibition, curated by Michaela Wetherell, which displays images of unknown women in the Darlington Borough Art Collection in Crown Street and 'considers what they are saying to us now'. This one is by Mircea Cirtog.

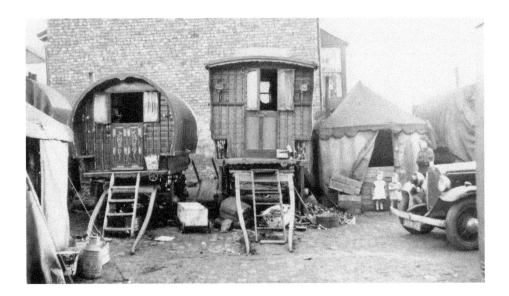

Gypsy Caravans

Caravans parked in Northern Yard, Valley Street North. *The Spectator* explores some of the lesser-known or appreciated facts about the travelling community (Katharine Quarmby, 24 August 2013).

'Billy Welch, a *sherar rom* or elder within the community, organises Appleby Horse Fair every year in Cumbria, which attracts about 10,000 from the community and a further 30,000 tourists. He told me that the links between entrepreneurial Gypsy men and the Freemasons are also helpful for business. Showing me his intricate masonic ring, he said: "This was my father's ring, he was one too. Freemasons aren't anti-Gypsy; the thing I like best about Freemasonry is that in it all men are equal..." Billy Welch comes from Darlington, a town known as the "Gypsy capital" of the UK, as it's estimated that around a third of the population has Romani roots.'

Bucktons Yard today is shown in the new photograph.

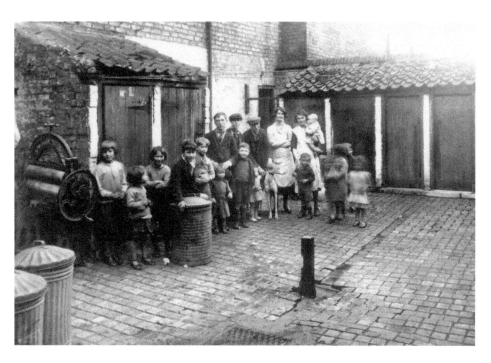

George's Square Backyard
Slum conditions in 1934 Darlington, off Bridge Street with overcrowding, insanitary conditions and facilities, and disease.

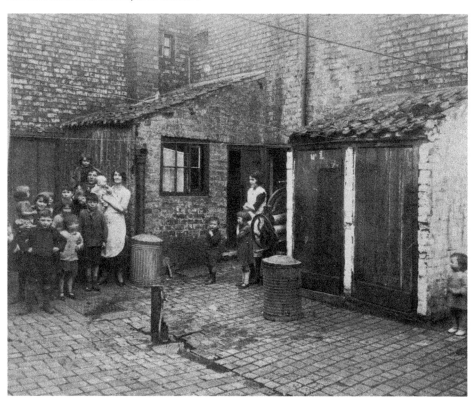

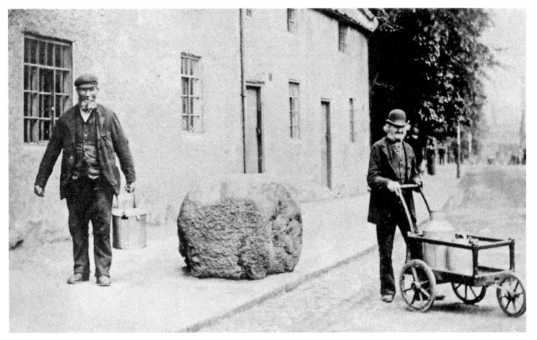

Bulmer's Stone

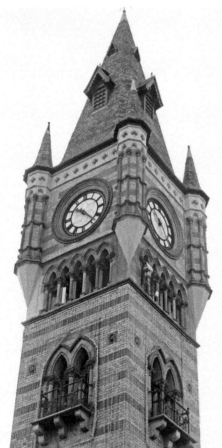

Bulmer's Stone is a large, square-shaped boulder of pink Shap Fell granite or glacial erratic left behind at the end of the Ice Age, and it once marked the northern edge of Darlington. The name derives from one Willy Bulmer, the borough town crier who shouted out news from it. It was also known as the 'Battling Stone' after the town's weavers, who beat their flax upon it. It also features in the following ancient rhyme, 'when the boulder hears the clocks strike twelve the Bulmer Stone turns around nine times': 'In Darnton towne ther is a stane, And most strange is yt to tell, That yt turnes nine times round aboute When yt hears ye clock strike twell.'

Here it is outside cottages in Northgate before they were demolished to make way for the Technical College in 1897. It's still there, but you have to look carefully. A close-up of the clock tower is in the lower picture.

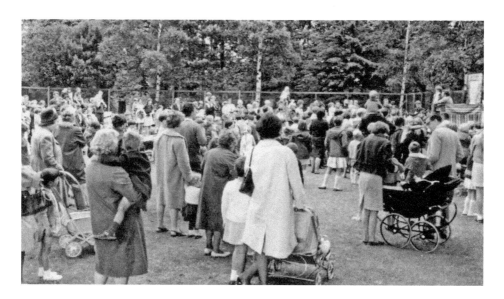

South Park

South Park was the first municipal Victorian Park in the north-east of England. The Historic England website gives us a history: 'In his will, dated 1636, Sir James Bellasses left a 10ha copyhold farm, Poor Howdens Farm, to the town for charitable purposes. In March 1850, the trustees of the charity recommended that the greater part of the farm 'be used as a park or promenade and a recreation ground for the public at large'. The suggestion was confirmed at a public meeting and in 1851 the land, now the southern part of South Park, was leased to the Board of Health for twenty-one years. The trustees contributed £100 towards its laying out and further funds came from Joseph Pease of Hutton Hall. The park, named Bellasses Park, was opened two years later ... the Corporation purchased the site for £3075. Under their ownership it became known as People's Park and then South Park.' The lower picture shows the opening of Darlington's light railway in 1904.

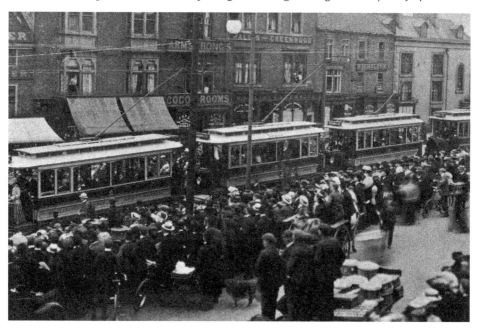

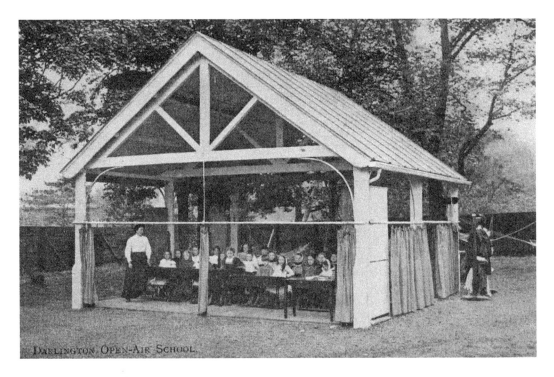

DARLINGTON OPEN-AIR SCHOOL.

The Open-Air School

This unconventional educational establishment was on Gladstone Street. Here pupils can be seen 'enjoying' the open air, indifferent weather and their lessons. Unfortunately, it was the mediocre weather that put paid to the experiment soon after its opening in 1910. The Ladies Training College in the lower picture was built in 1875 to accommodate and train seventy-five mistresses with a view to turning them into teachers. More recently it was home to Darlington Arts Centre.

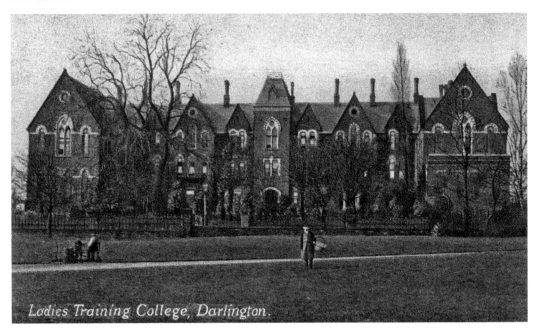

Ladies Training College, Darlington.

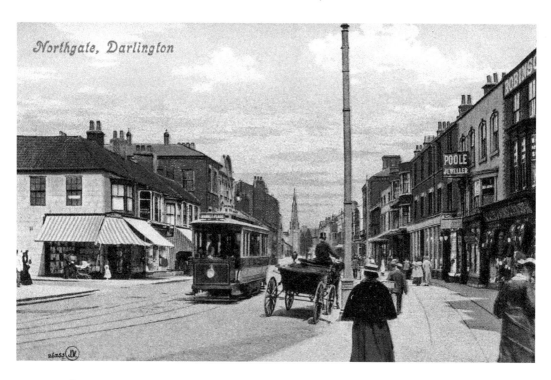

Northgate, Darlington

Northgate

The top images shows a busy Northgate with a tram on its way to Market Place. The lower image shows brightly coloured shops in Northgate today.

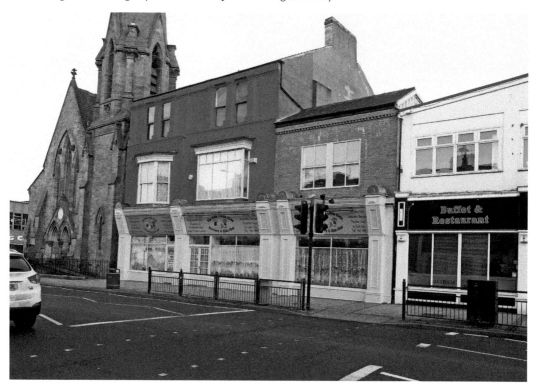

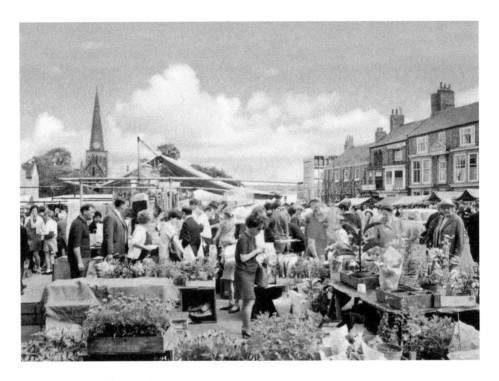

Flower Stalls at the Market
Meat and fish in today's Market Hall.

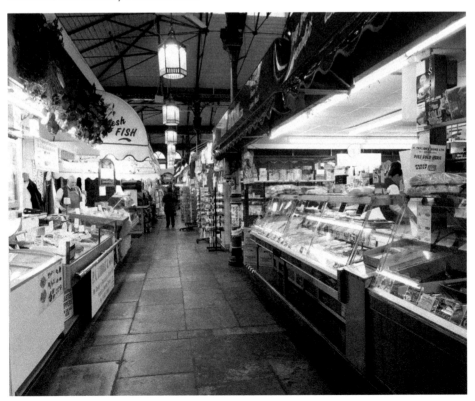

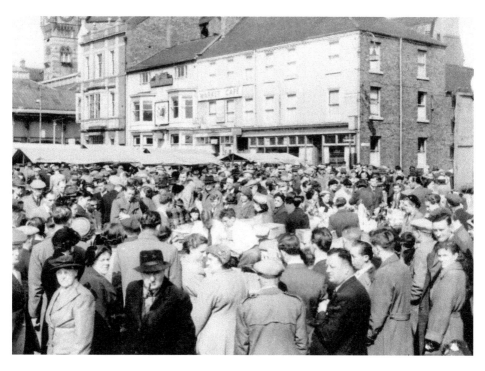

Bulls Market Day
Bulls Market Day in Darlington in 1954 when the Collinsons ran the Bull's Head Hotel in the centre of Bakehouse Hill – the Bull's Head is on the right.

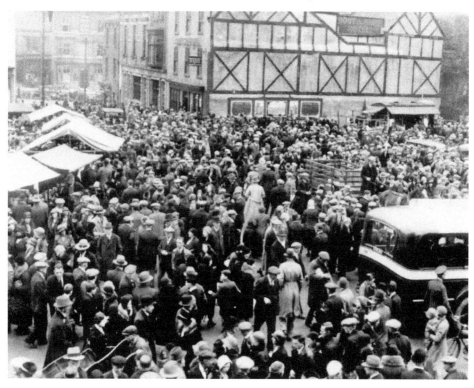

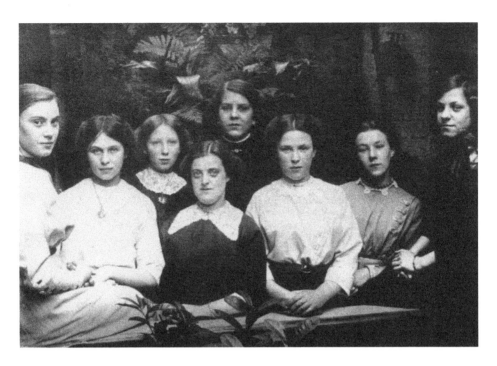

Marks & Spencer

The eight staff of the branch of Marks & Spencer's Penny Bazaar, which opened at No. 8 Prospect Place in December 1911. These penny bazaars sold everything for 1*d*. The manager was Miss Violet Rutter, fourth from the left.

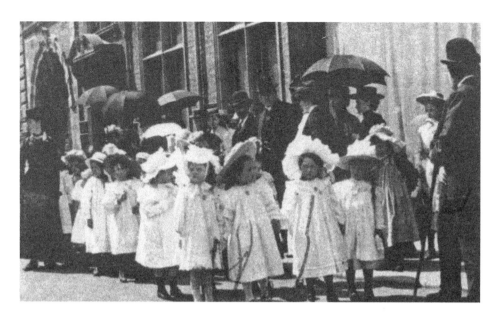

St Augustine's Children

In 1908 these children assembled outside the County Court in Coniscliffe Round before their procession of witness. Monsignor James Rooney is in the middle – he was parish priest from 1876 to 1931. The lower photo shows one of the plaques on the Joseph Pease statue. This one reflects his interest in, and active promotion of, education. The others depict politics, the railways and the abolition of slavery.

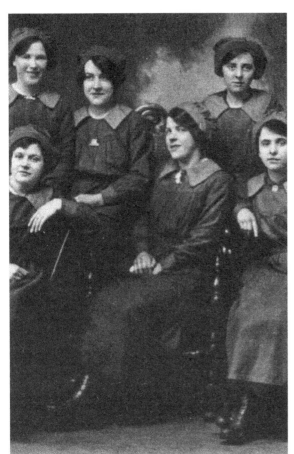

Munitionettes

In early 1914 the North Eastern Railway in Darlington employed over 2,250 men. During the war it was rebadged as the Darlington National Projectile Factory focussing, as the name suggests, on the production of shells. Over 1,000 people, mainly women, worked there doing invaluable work – and playing some serious football.

In nearby Middlesbrough Bolckow Vaughan's Munitionettes team were runners-up in a replayed final tie for the Tyne Wear & Tees Alfred Wood Munition Girls Cup. Unfortunately, they were beaten 5-0 by Blyth Spartans. Other clubs in the region included Dorman, Long & Co; Teesside Ladies; Ridley's, Skinningrove; Skinningrove Ironworks; Smith's Docks; Richardson, Westgarth (Hartlepool); and Christopher Brown (West Hartlepool). These were not just casual kick-arounds but highly organised matches played at such prestigious venues as Ayresome Park and St James's Park. By 1918 there were more than 900,000 munitionettes producing 80 per cent of the weapons and shells used by the British Army.

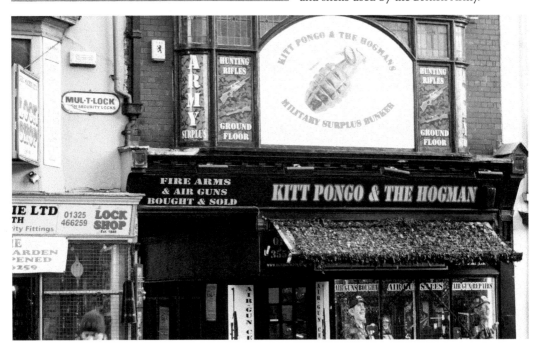

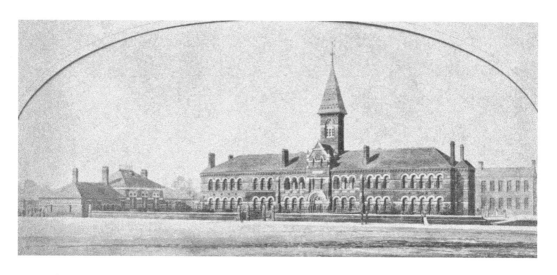

The Workhouse

For some, it was but a short step from this abject poverty to the even worse horrors of the workhouse. We know from a 1777 parliamentary report that a workhouse for 100 inmates existed in Darlington. Then in Lead Yard a converted bishop's palace, built in 1167, was purchased from the bishop to be used as a workhouse. In 1867 a new building was erected in Yarm Road for 250 inmates and fifty vagrants, pictured here. In the 1894 investigation by the *British Medical Journal*, Darlington workhouse was found to 'leave little to be desired'. It recommended that a night nurse be appointed and day staff be increased; that the idiots and imbeciles be separated from the sick and infirm; that venereal cases be kept separate; and that a paid attendant be hired for infants and night cots be provided. Ventilation also needed to be improved. The modern image shows Clarks Yard today.

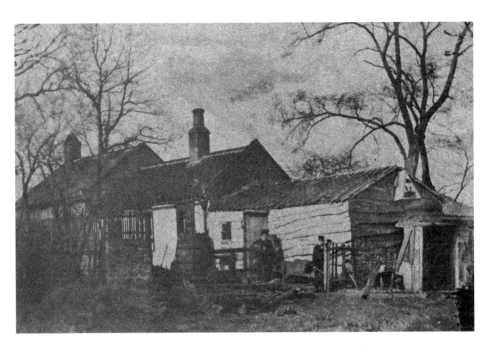

Pinder Bank

Pinder Bank is shown here in 1856. Situated on the east side of the Stone Bridge, this was the place where stray livestock were impounded and only released on payment of a fine – it was all administered by the Bishop of Durham. The cottage here was a farm and bleaching shed. Horsemarket is one place the beasts may have escaped from.

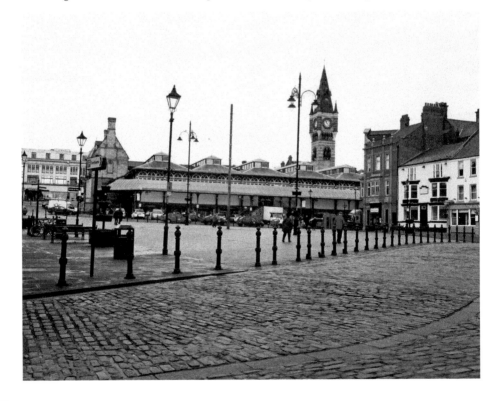

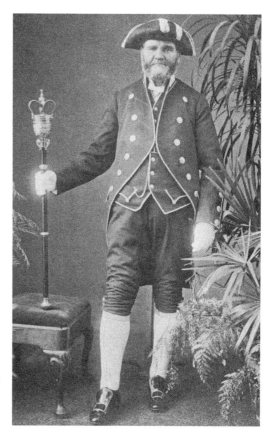

John Donnison

This fine gentleman, resplendent in his town crier uniform, is John Donnison, Darlington's first bellman, in 1867 when borough status was achieved. Donnison later became mace bearer. The lower images shows another of the panels on the Joseph Pease statue – this one illustrating the abolition of slavery.

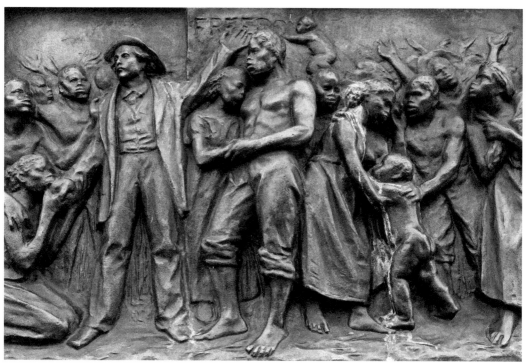

43

Horesfair in Bondgate

A gypsy caravan can be seen on the left of the upper photo taken in the early twentieth century. The gypsies would have been active in selling their horses. Bondgate was originally a separate manor from the borough of Darlington. Bondgate landowners held their land by bond tenure while borough people were freeholders.

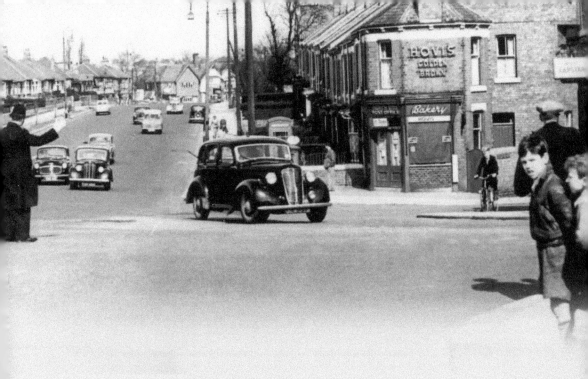

CHAPTER 4

Civic Services & Amenities

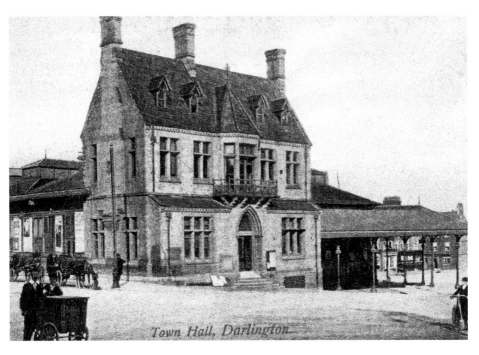

Town Hall, Darlington

The Second Town Hall

Joseph Pease (b. 1799) gave the Old Town Hall to the town in 1853; he added the Clock
Tower and Covered Market in 1864. The town hall we see today was opened by Princess
Anne in 1970 (*see* page 96).

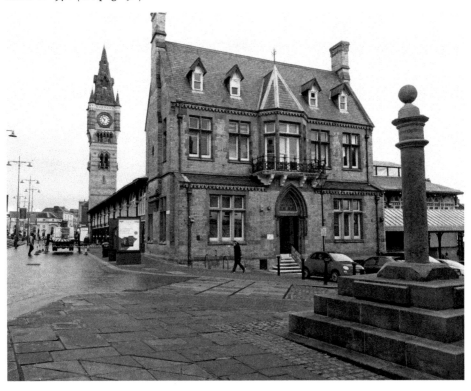

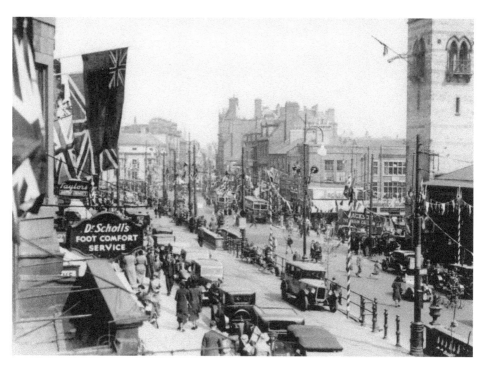

Darlington Police
A policeman on point duty on Whit Monday in 1985. There's another policeman on traffic duty on page 45 – a thing of the past.

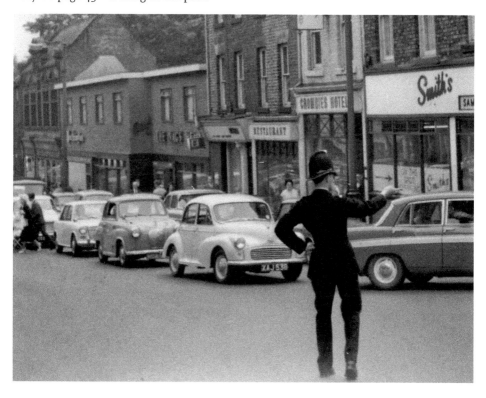

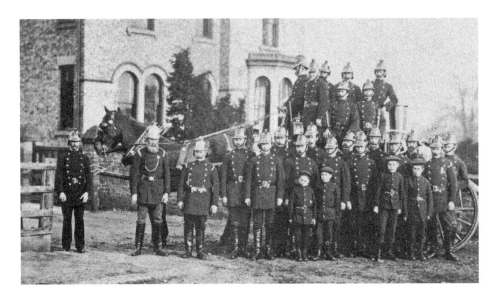

The Great Fire of Darlington

A disastrous fire started on 7 May 1585 around midday and spread rapidly through the wooden straw-roofed houses. Water was scarce at the time due to a drought and people frantically used milk and beer in an attempt to dowse the flames. A total of 273 houses were destroyed and 800 people were rendered homeless. The upper image shows the Darlington Fire Brigade in 1880, run by volunteers. The steam fire engine was donated by Joseph Pease in 1870. The shot was taken outside Polam Grange, the home of John Bowman, Honorary Captain of the brigade in Polam Road. The lower picture shows firefighters fighting Pease's Mill Fire in 1933. The mill was built in 1872 in Priestgate and demolished in 1964. The distinctive octagonal chimney survived for a while as a listed building, but was knocked down regardless. The mill, of course, was a symbol of the town's woollen industry.

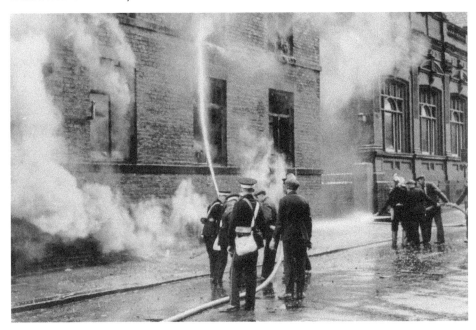

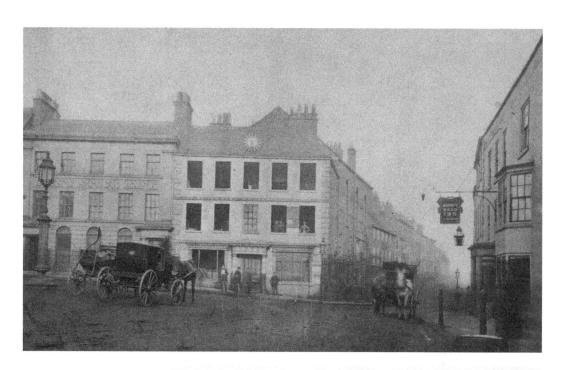

The Sun Inn

The Sun Inn was demolished to make way for an extension to the bank, which can be seen behind the statue in the new photograph.

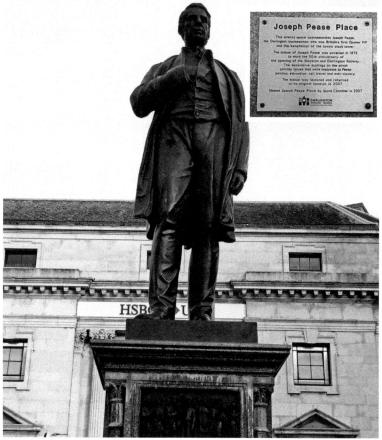

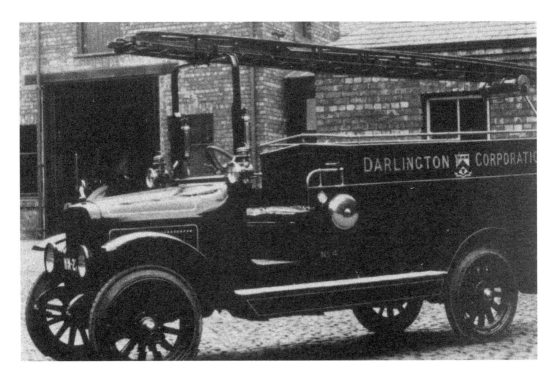

The Escape Ladder

The top image shows Darlington Corporation's Fire Brigade Escape Ladder No. 4 at the fire station in Borough Road. It boasted a warning bell, ladder and two extinguishers. The lower image shows a Darlington Triumph Services bus. Much of the fleet consisted of ex-military vehicle chassis with new bodywork.

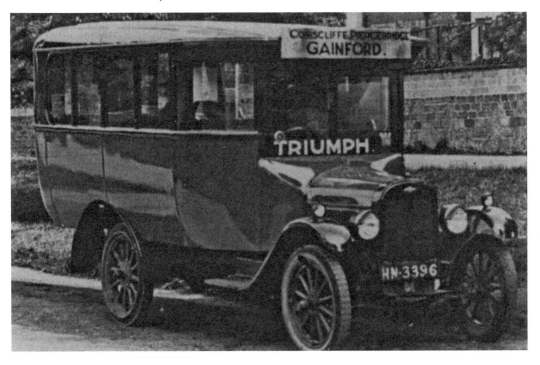

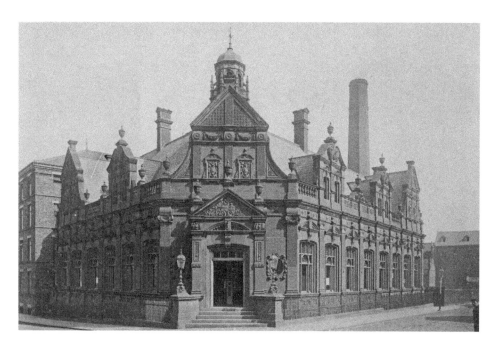

Darlington Library

Darlington Library is in Crown Street. It was a gift to the town from Edward Pease (1834–80). He left £10,000 in his will to build a free library in Darlington, which was officially opened on 23 October 1885 by his daughter, Lady Lymington. Sadly, the library's closure was announced in 2016.

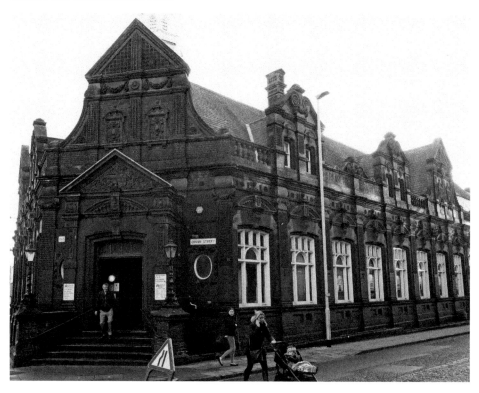

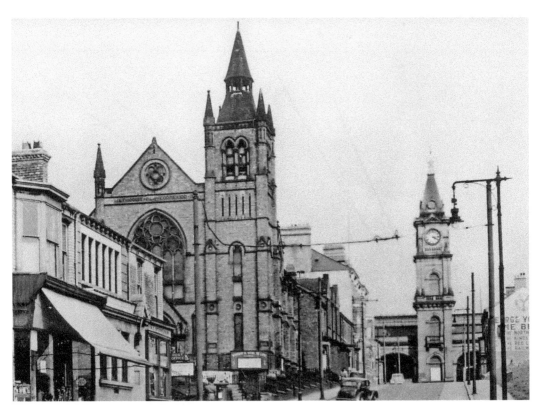

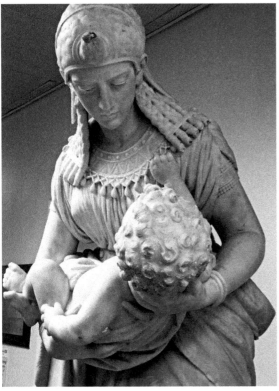

Victoria Road and *Pharaoh's Daughter* by Giovanni Battista Lombardi

The New Methodist Connexion Church stands prominent on the left. On the sixth floor of the Memorial Hospital you can see one of Darlington's most beautiful and little-known treasures. Carved in Rome from white marble, *Pharaoh's Daughter* by Giovanni Battista Lombardi (1822–80) shows Thermuthis, the pharaoh's daughter, at the point she discovered Moses, whom she adopted as her own son – today it graces the entrance to the maternity and baby care units of the hospital. It was originally owned by Alfred Backhouse of Pilmore Hall, now the Rockcliffe Hall Hotel. On the death of the (childless) Backhouses, Elizabeth Barclay Backhouse gifted the sculpture to Darlington Hospital in their memory. For many years the sculpture stood at the entrance to Greenbank Hospital, which was built on the site of Alfred and Rachel Backhouse's former home and became the town's maternity hospital.

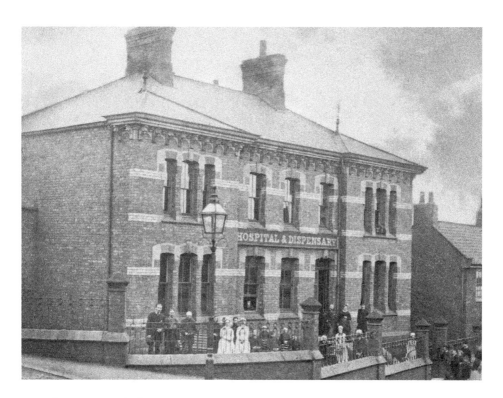

Russell Street Hospital

The hospital opened in 1865, replacing the Dispensary. Here it is in 1880. It was superseded in 1874 by the Hunden's Lane Isolation Hospital and in 1885 by the Greenbank Maternity Hospital. It then became the Conservative Club. Soon after, Darlington Hospital and Dispensary opened on Russell Street. A Red Cross hospital was on Skinnergate in the early twentieth century. Darlington Memorial Hospital was officially opened in 1933 by Prince George (later the Duke of Kent). Hunden's Lane Hospital later became an ear, nose and throat hospital before its closure. Greenbank Maternity Hospital also closed, in 1989, and both have been demolished. The image shows the children's ward in Greenbank Hospital in 1930.

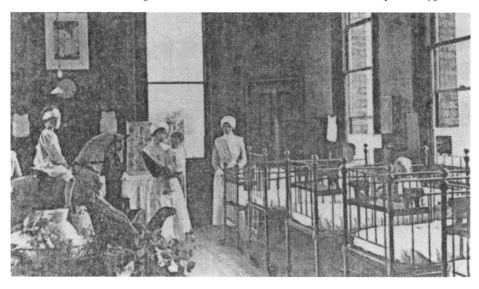

St Cuthbert's Church of England School

Shot in 1900, this photograph shows the school in Leadyard. St Cuthbert's was established in 1812 and this building opened in 1824. It was the first school in Darlington to provide ongoing education for poor children. It closed in 1931 and was demolished in 1933. The lower card pictures the Grammar School in around 1910. When, in the early 1870s, the Duke of Cleveland's estate was developed, part of it was used to create Stanhope Park and the Grammar School of Queen Elizabeth in 1875. The school took in boarders and featured an undercroft playground at one end.

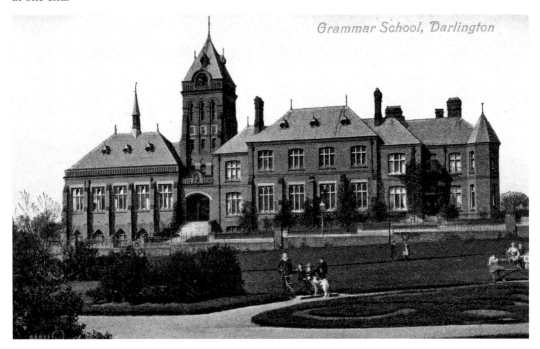

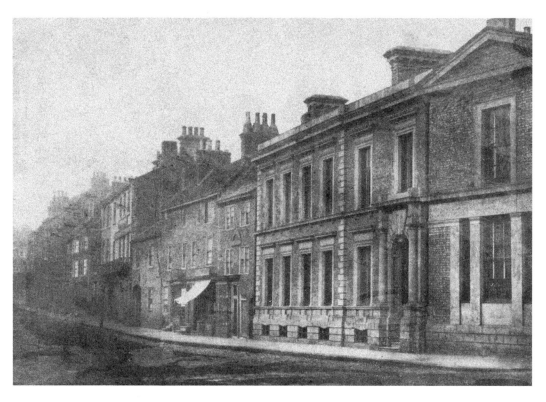

The Railway Offices, Northgate

The Railway Offices were built in 1830 as the headquarters of the Stockton & Darlington Railway and then of the North East Railway until 1915. A shot of 65033 is in the lower picture, restored at Shildon. (©Stan Laundon)

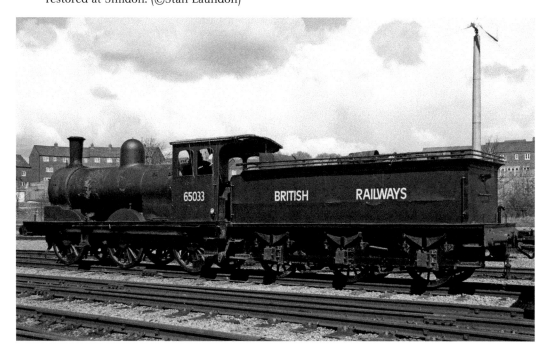

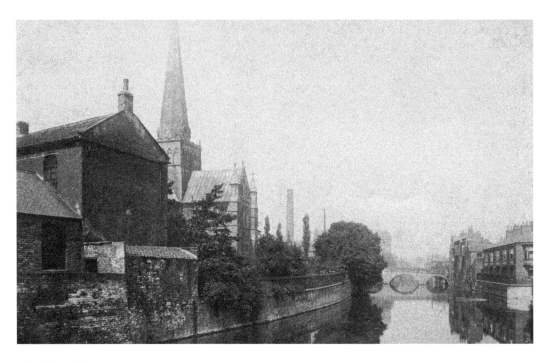

The River Skerne

Photographed in 1913, this shows the river and the Stone Bridge in the centre with Pease's Mill chimney and St Cuthbert's clearly visible. Leadyard and the National School are on the left with Prior's Terrace on the right bank. The Skerne is around 25 miles long and rises in magnesian limestone hills between Trimdon and Trimdon Grange, ending at Hurworth Place where it joins the River Tees. The Skerne flows under seventeen bridges in Darlington and lends its name to the Skerne Park estate in Darlington. The lower image shows the Higher Elementary School.

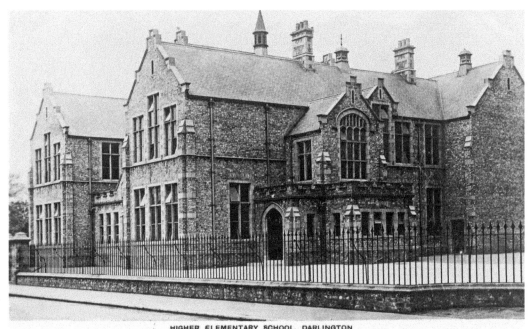

HIGHER ELEMENTARY SCHOOL, DARLINGTON

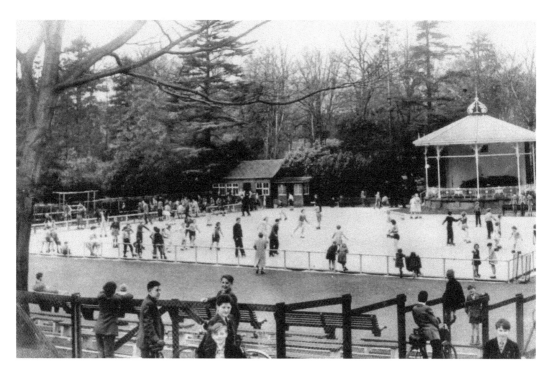

The South Park Roller Skating Rink and the Theatre Royal
The lower image is a superb card showing the Theatre Royal on the left, which opened in 1885. In 1938 it was refurbished and became the Regal Cinema; after that it was the ABC, Cannon and MGM. The Regal Cinema opened with Spencer Tracey in *Captains Courageous*. The seating capacity was 1,620 in stalls and circle.

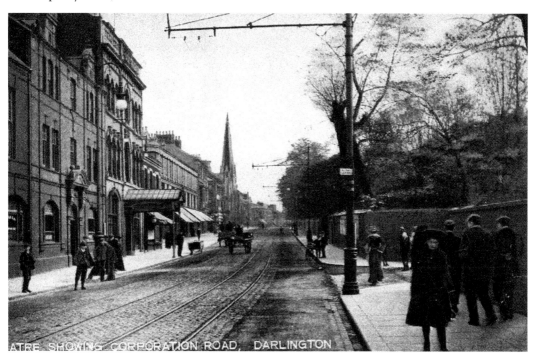

ATRE SHOWING CORPORATION ROAD, DARLINGTON

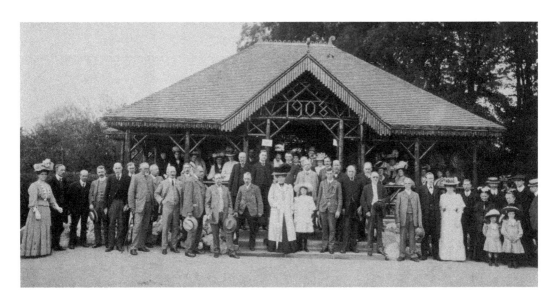

The South Park Teahouse and the New Hippodrome
The South Park Teahouse opened in 1908. The park was laid out over 108 acres. The New Hippodrome and Palace of Varieties is in the lower image, opened in 1907 by Rino Pepi. It later became the Civic Theatre in 1966 when the council took it over.

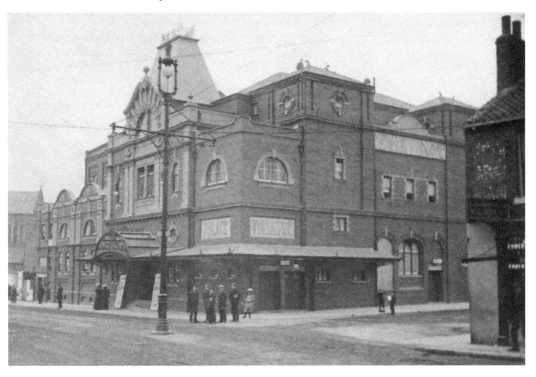

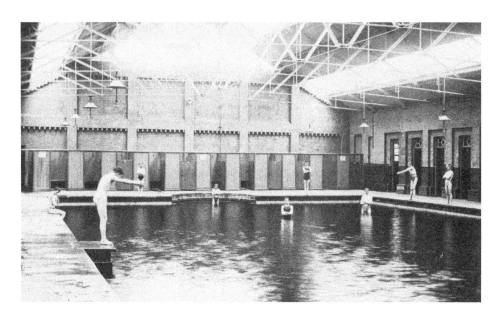

Kendrew Street Baths

The baths opened in 1851, were covered over in 1888 and refurbished with a 'New Bath' in 1933. In 1932 mixed bathing was allowed. Prince George, later the Duke of Kent, visited Kendrew Street (Gladstone Street) Baths on 5 May 1933. Today, swimming and numerous other sport and leisure activities take place in the Dolphin Centre, opened in 1982 by Sir Roger Bannister on the site of the Dolphin public house to make one of the largest leisure centres in the North of England; before that the Gladstone Street and Kendrew Baths hosted wrestling events. The central hall of the Dolphin Centre was originally built in the late eighteenth century as a Quaker meeting house. It was then used as a cinema, then the old rents and rates hall.

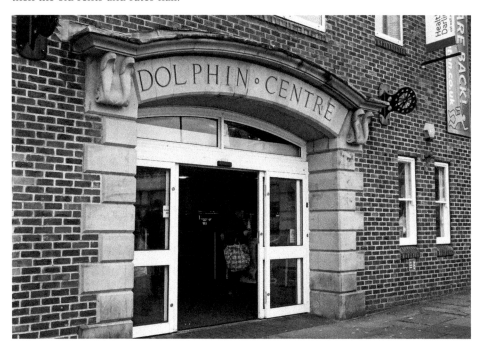

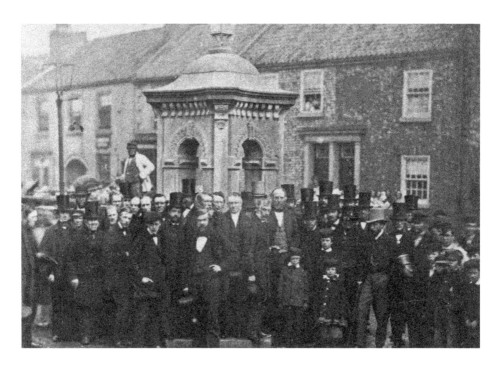

Darlington Total Abstinence Society

On 10 June 1862 the society unveiled this drinking fountain in honour of John Fothergill MRCS, their first president, who died in January 1858. The fountain was in Bondgate opposite Skinnergate, but was moved to South Park in 1875. The modern image shows one of the public drinking fountains, in Millbank Road.

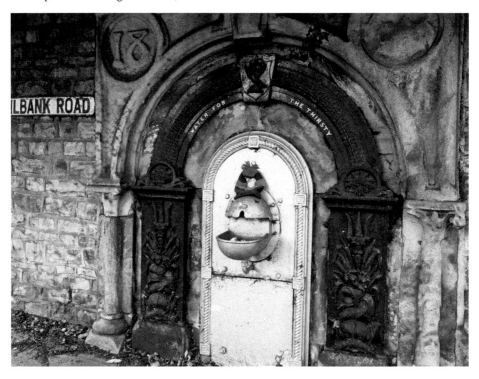

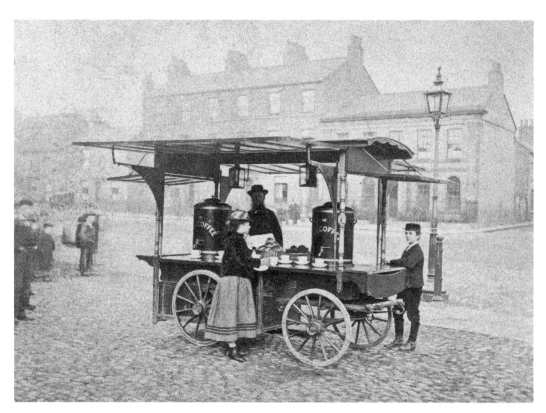

The Temperance Coffee Cart

This cart was one of the valiant attempts by the Quakers to deter Darlington drinkers run by the Coffee Cart Co. A similar operation was launched in York under the auspices of the Quaker Rowntrees. The cart is in Bondgate, near Salt Yard; the houses in the background were demolished to make way for the Majestic Cinema, later the Odeon. The Temperance building in Gladstone Street is in the modern photo.

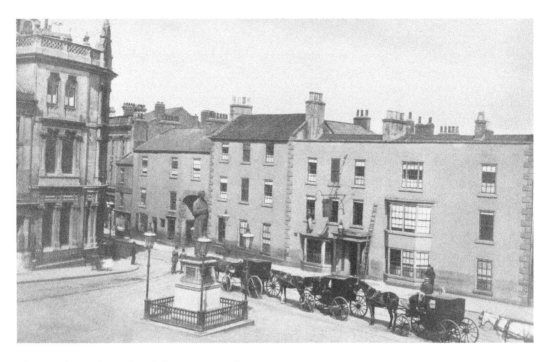

The King's Head Hotel and the Hat & Feather

The King's Head is shown here in 1889. The Hat & Feather Inn was in Church Row; it lost its licence in 1891 to The Trevelyan, which was renamed The Imperial. When, in 1893, the Hat & Feather was given to the council, the condition was that the pub and two adjoining cottages were demolished within six months and the site added to the Market Place and 'forever hereafter to be kept as an open space and unbuilt upon'. Other sources say that the pub was demolished to improve the view of St Cuthbert's Church.

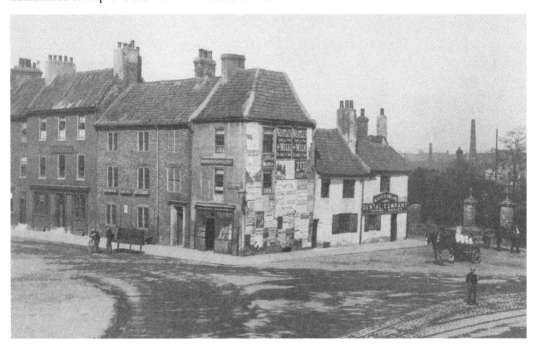

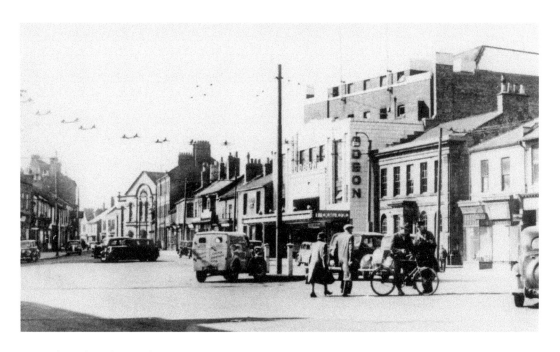

The Odeon in Bondgate

In 1939 Darlington had the most cinema seats per head in the United Kingdom. The art deco 1930s building was originally called the Majestic. The Majestic Cinema opened on 26 December 1932 with Nancy Brown in *Maid of the Mountains*. There was seating for 1,039 in the stalls and 541 in the balcony. It was taken over by Odeon Theatres Ltd on 16 July 1943 and renamed Odeon on 9 April 1945. The new photo shows Darlington's Majestic in 2017.

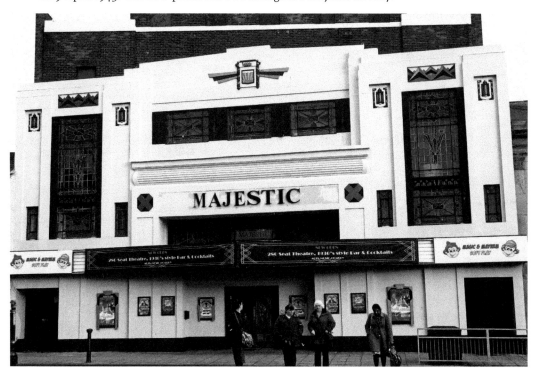

The Burns Hotel and the North Eastern Hotel
The Burns Hotel, a Samuel Smiths pub in Northgate, and the North Eastern Hotel in Victoria Road. The Burns closed in 1969 and was demolished to make way for the ring road.

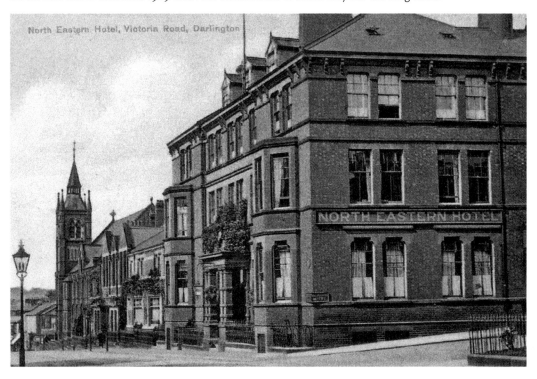

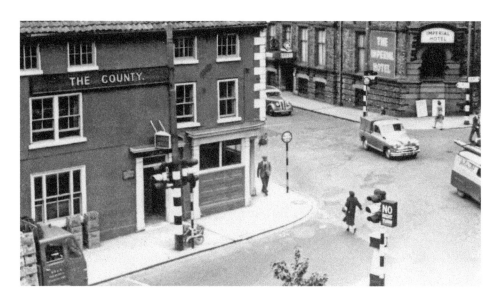

The County Pub and the Imperial Hotel

Some lost Darlington pubs with the date of closure and location:

Alexandra, 1978, Whessoe Road; **Birds Nest**, Gladstone Street; **Bishop Blaize**, 1912, Clay Row; **Black Bull**, Bakehouse Hill; **Black Lion**, 1911, Clay Row; **Blacketts**, Bondgate; **Bowes**, Skinnergate; **Brannigans**, East Street; **Bridge**, 1990s, High Northgate; **Brown Trout**, 2010, West Auckland Road; **Caledonian**, 2009, High Northgate; **Central Borough**, Hopetown Lane; **Cleaver**, *c.* 1970, Skinnergate; **Cricketers Hotel,** *c.* 2013, Parkgate; **Firth Moor Hotel**, 1990s, Burnside Road; **Fleece Hotel**, Blackwellgate; **Forge Tavern**, *c.* 2008, Nestfield Road; **Globe**, *c.* 2000, Whessoe Road; **Grampian**, *c.* 1990, Pensbury Street; **Greentree**, 1950s, Skinnergate; **Havelock Arms**, 1998, Haughton Road; **Hope Inn**, Yarm Road; **Jack Horners**, Whitby Way; **Lascelles Park**, Fenby Avenue; **Locomotive**, *c.* 2000, Whessoe Road; **Newton Kyloe**, Cockerton Green; **Old Coaching House**, *c.* 1983, Houndgate; **Old Dunn Cow**, Post House Wynd; **Raby**, Tubwell Row; **Railway Hotel**, *c.* 1999, Otley Terrace; **Royal Oak**, *c.* 2008, Yarm Road; **Star**, 1911, Allan Street; **Three Tuns Inn**, Northgate; **Waterloo**, 1974, Market Place; **Woolpack**, *c.* 1969, Freemans Place.

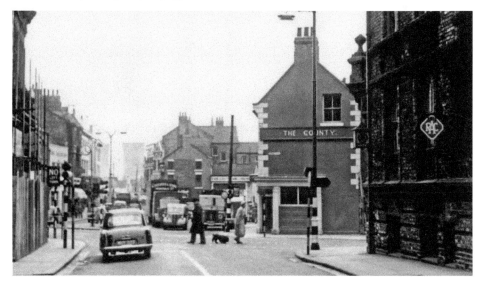

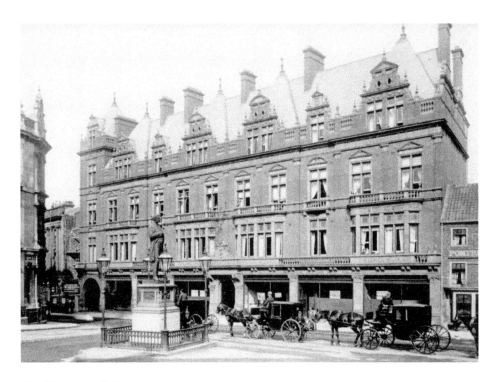

The King's Head 1893
This famous coaching inn was demolished and replaced by the King's Head we see today. The shareholders of the Stockton & Darlington Railway held their inaugural meeting in the original King's Head – the company had their offices here in two rooms.

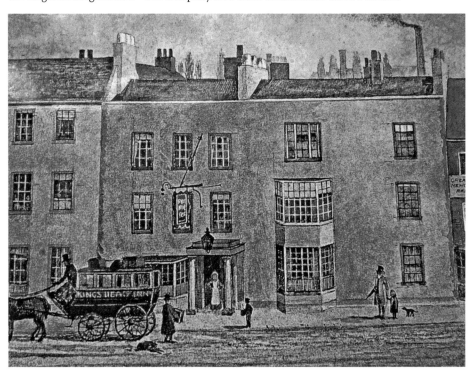

The Leeds Arms

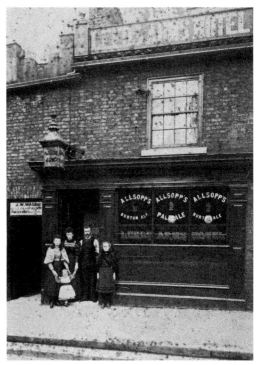

The image shows the Leeds Arms in Northgate, taken in 1894, showing the licensee, Mr Wade, and his family. Before it was the Leeds Arms the pub was known as The Rifle and The Rifle Volunteer. Samuel Allsopp & Sons was one of the largest brewery companies operating from Burton upon Trent. In 1861 Allsopps was the second largest brewery after Bass. In 1822 Allsopp successfully copied the India Pale Ale of Hodgson, a London brewer. In 1935 Samuel Allsopp & Sons merged with Ind Coope Ltd to form Ind Coope and Allsopp Ltd. The Allsopp was dropped in 1959 and in 1971 Ind Coope became part of Allied Breweries. The Bridge in Northgate can be seen here to the left of the Odeon.

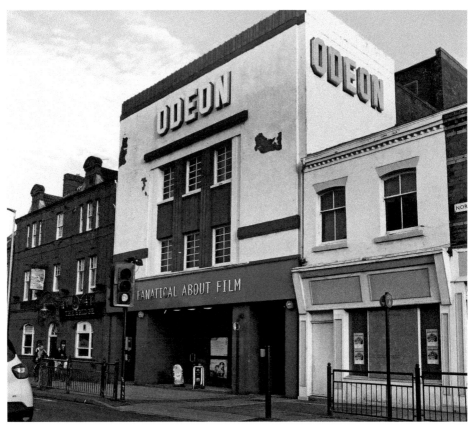

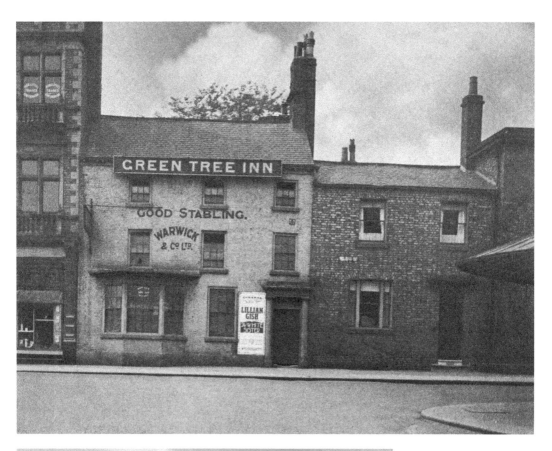

The Green Tree Inn

At Skinnergate and Blackwellgate. Lillian Gish's latest film, *The White Sister*, is advertised on the billboard, playing at the Central Hall Cinema. Out the back, Green Tree Field was home to a wooden theatre. In 1859 the first show of the Darlington Horse and Foal Society was held in the field. Pink Candy is in the lower image.

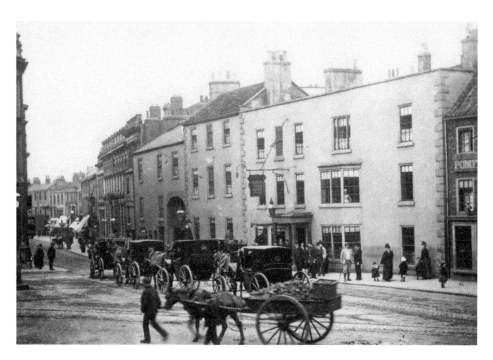

The King's Head, 1889

August 2008 saw the King's Hotel devastated by a fire, which severely damaged the roof and 100 bedrooms. Several adjacent shops, including Woolworths, were damaged. The hotel was restored to its former glory in 2012.

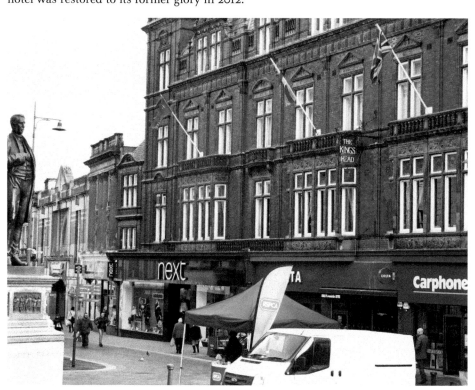

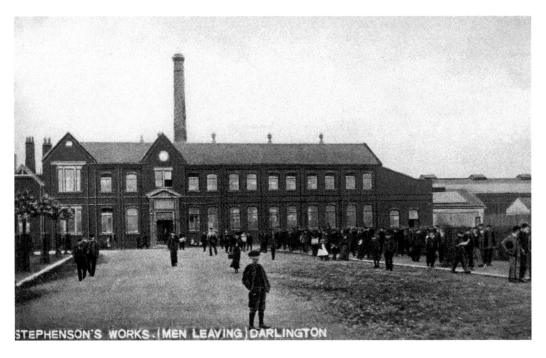

Robert Stephenson's & Co.

The company moved to Darlington from Newcastle in 1902; it built steam engines for locomotives. This upper image shows the factory at knocking-off time. The lower image is of the restored *Sir Nigel Gresley* passing through Eaglescliffe. (© Stan Laundon)

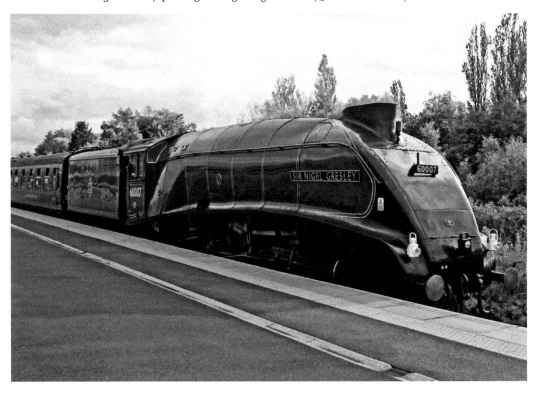

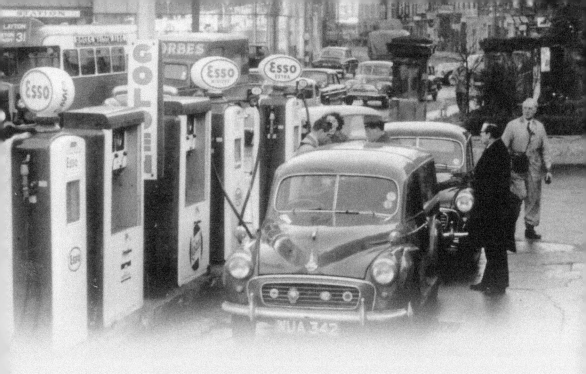

CHAPTER 5

Darlington on the Move – or Not

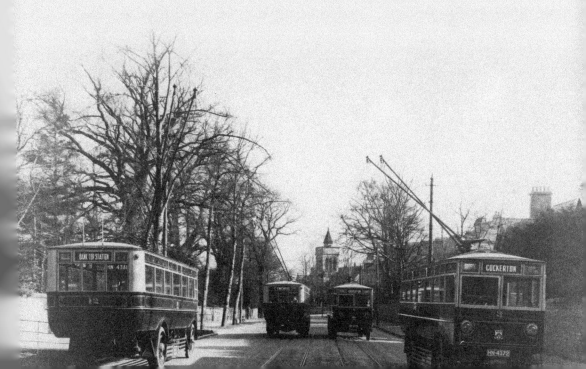

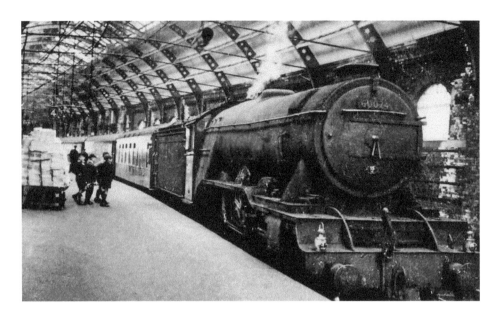

Trainspotting at Darlington Station, 1961

The first railway here was built by the Stockton & Darlington Railway – the mineral branch from Albert Hill Junction on the main line to Croft-on-Tees – on 27 October 1829 and bought by the Great North of England Railway in 1839 to incorporate into their new main line from York, which reached Darlington in 1841. The Newcastle & Darlington Junction Railway extended the new main line north to Newcastle. The two routes met at Bank Top Station, rebuilt in 1860. By the mid-1880s this was inadequate and so in 1897 the NER constructed a new station on the Bank Top site with new sidings and goods lines and a new connecting line from the south end of the station to meet the original S&D line towards Middlesbrough at Oak Tree Junction near Dinsdale. The lower image shows the fully restored GWR 0-6-0 Pannier Tank engine No. 5775 decked out at Shildon. (© Stan Laundon)

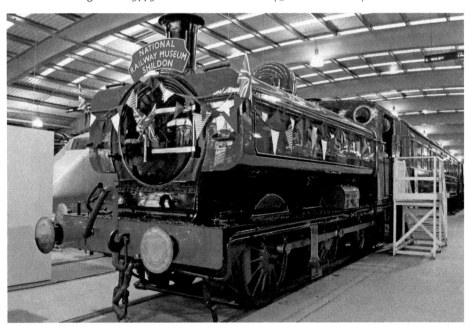

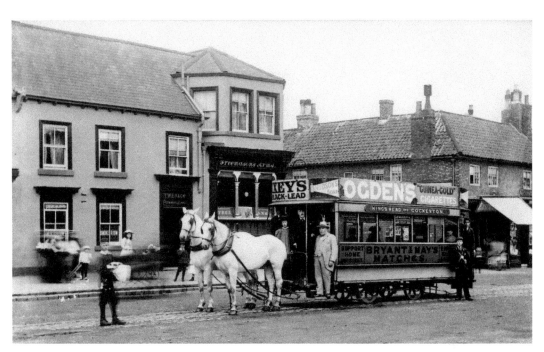

Stockton & Darlington Steam Tramways Co. Horse-Drawn Tram
A 3-foot gauge tram outside the Freemasons' Arms on Bondgate around 1900. The man in the sharp white suit was probably from Imperial Tramways, the company's owners. The horse-drawn service was ended in 1903. In 1862 Darlington was the first town to run tramways in the North East and Yorkshire when American entrepreneur George Francis Train laid down the groundbreaking tracks here. Miss Pease is photographed here with her donkey outside her house in Stockton.

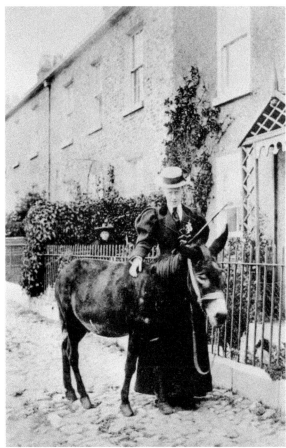

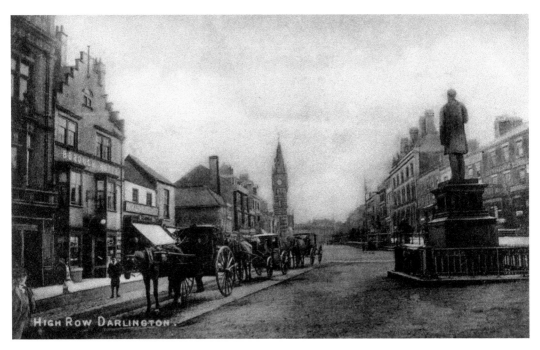

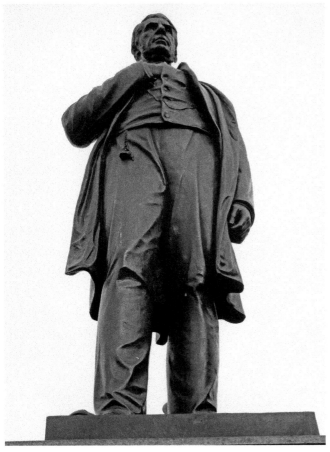

Borough Hotel, Horses and Traps

The top image shows horses and traps providing a taxi service outside the Borough Hotel on High Row. Joseph Pease surveys High Row in the lower photograph. The top image on page 71 shows the Esso garage on Grange Road. Note the helpful attendants taking payments and wiping your windscreen – services that are long gone.

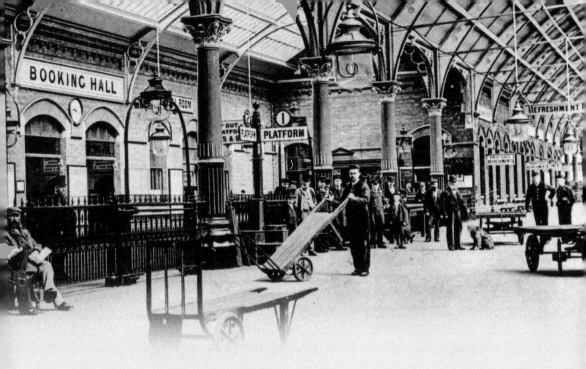

CHAPTER 6

A Darlington Miscellany

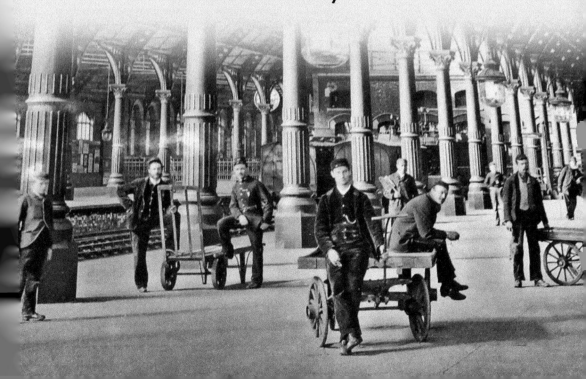

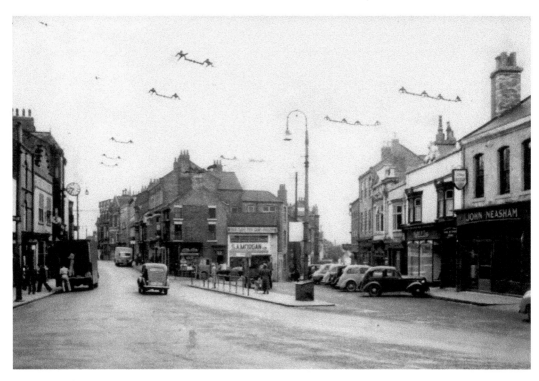

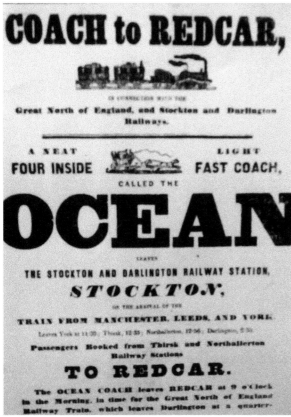

COACH to REDCAR,

IN CONNECTION WITH THE

Great North of England, and Stockton and Darlington Railways.

A NEAT LIGHT

FOUR INSIDE **FAST COACH,**

CALLED THE

OCEAN

LEAVES

THE STOCKTON AND DARLINGTON RAILWAY STATION,

STOCKTON,

ON THE ARRIVAL OF THE

TRAIN FROM MANCHESTER, LEEDS, AND YORK.

Leaves York at 11:30; Thirsk, 12:35; Northallerton, 12:56; Darlington, 2:35;

Passengers Booked from Thirsk and Northallerton Railway Stations

TO REDCAR.

The OCEAN COACH leaves REDCAR at 9 o'Clock in the Morning, in time for the Great North of England Railway Train, which leaves Darlington at a quarter-

Blackwellgate, 1950

The parish of Blackwell owes much to the woollen industry. Blackwell Mill dates from around 1183, and was described as one of the 'finest old mills in the north of England'. With the land owned by the Bishop of Durham, all Blackwell farmers were obliged to grind their corn there until Darlington Council bought the bishop out for £2,500 in 1863. The mill survived until 1907, and was demolished in 1938. The waters of the Skerne and the Tees were famous for their bleaching properties. Walk Mill Nook was on the Skerne near Snipe House. A 'walker' trampled on the cloth to stretch and flatten it in a large water-filled trough. Anyone called Walker today owes their name to this activity. The premises of John Neasham, motor dealer and director of Darlington Football Club, is on the right. The bill advertises one of the earliest railway excursions to Redcar.

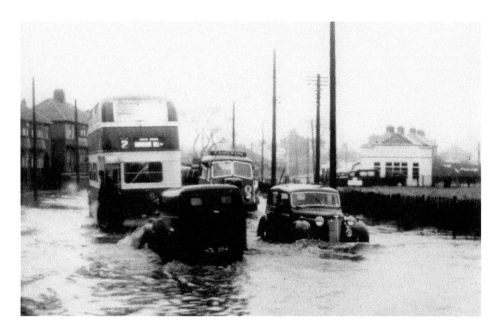

Haughton Road

Flooded in March 1963 with a van, a No. 2 bus and a Cameron's of West Hartlepool dray negotiating the waters. Camerons Brewery Ltd was founded in 1865 by John William Cameron in West Hartlepool (now Hartlepool). Today it is the largest independent brewer in the North East. After a century of growth through acquisition, the company had an estate of 750 licensed premises throughout the North East and North Yorkshire by the 1960s. One of the acquisitions was Plews & Sons Ltd of Darlington, with 100 licensed premises. The new photo shows the Boot & Shoe in Horsemarket – still a Cameron's pub.

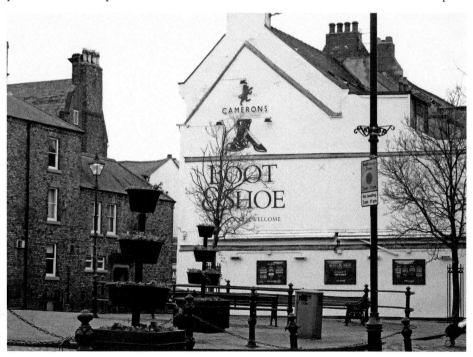

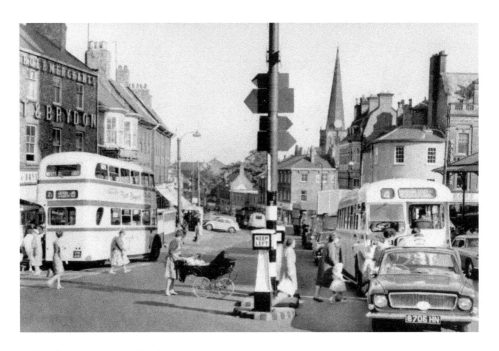

Tubwell Row, 1963, and Whessoe

The photo on page 75 was taken in 1926 in Woodlands Road when trolleybuses were the principal mode of public transport. The trolleybuses were joined by diesel buses in 1951 and phased out in 1957. Tubwell Row is where the global engineering firm of Whessoe started – way back in 1790 when Quaker William Kitching opened his ironmongers here. He went on to establish a successful foundry and engineering works with markets in the emerging railway, gasworks and steel construction industries throughout the nineteenth century up to today.

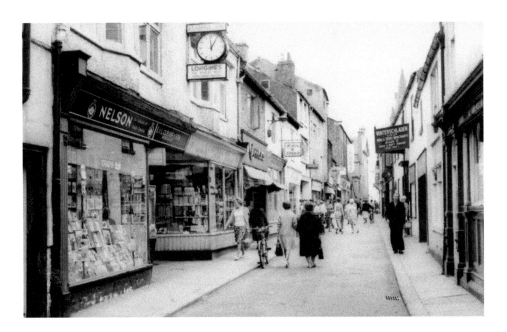

Post House Wynd

John Bartholomew's *Gazetteer of the British Isles* described Darlington in 1887: 'Darlington.– parl. and mun. bor., market town, par., and township, S. Durham, on river Skerne, 12 miles W. of Stockton-on-Tees, 36 S. of Newcastle, and 232 N. of London by rail – par., 7811 ac., pop. 36,666; township, 3351 ac., pop. 33,428; parl. bor. and mun. bor., 3910 ac., pop. 35,104; 4 Banks, 4 newspapers. Market-days, Monday and Friday. Since the opening of the Stockton and D. Ry., D. has been the centre of the industrial dist. of S. Durham. It has large iron and steel works, extensive locomotive establishments, breweries, tanneries, and some wool mills.'

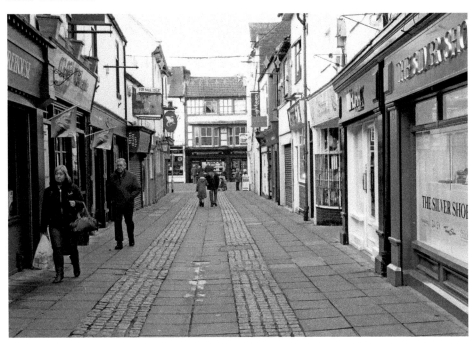

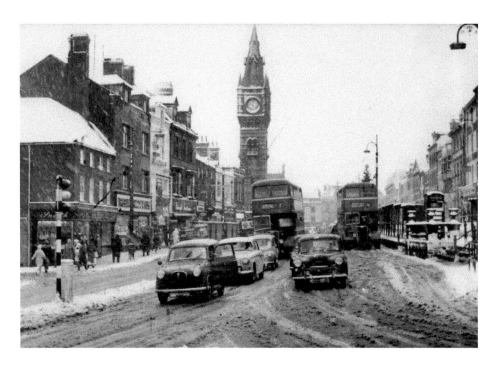

Big Ben's Sister

Darlington's most famous landmark is the clock tower, which was gifted to the town by the Joseph Pease in 1864. The clock face was manufactured by T. Cooke & Sons of York and the bells were cast by John Warner & Sons of Norton-on-Tees. These bells were sister bells to those that toll from inside the Elizabeth Tower at the Houses of Parliament, the most famous of which is Big Ben. The magnificent Barclays Bank, originally Backhouse's Bank in High Row, is in the modern photo.

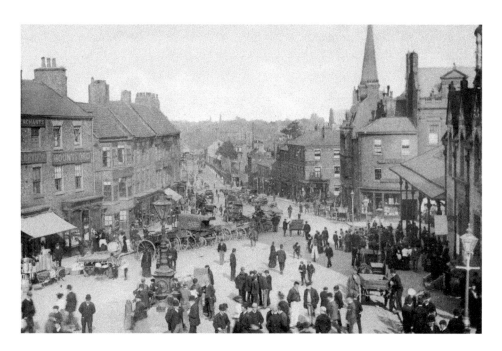

Tubwell Row, 1890

The old images shows market day, looking towards the Stone Bridge. This is how Celia Fiennes described Darlington in her *Through England on a Side Saddle in the Time of William and Mary, Being the Diary of Celia Fiennes* (1662–1741): 'From thence [Durham City] to Darlington wch is 14 pretty Long miles but good way, but by the way I Lost some of my night Cloths and Little things in a Bundle that the Guide I hired Carry'd. This is a Little Market town, the Market day was on Munday wch was the day I passed through it: it was a great Market of all things, a great quantety of Cattle of all sorts but mostly Beeves- it seemes once in a fortnight its much fuller.'

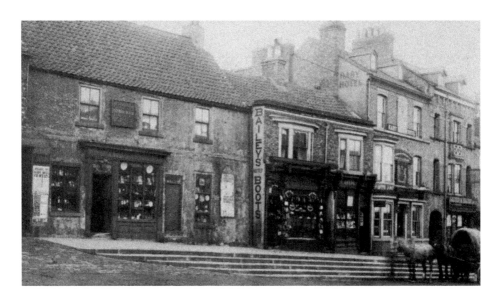

Tubwell Row II

The north side of Tubwell Row showing shops and the Raby Hotel, still there today on the site of the Old Pack Horse Inn. It was from here that Darlington's first cab hire service first operated. The Golden Cock is in the modern photo. The nearby market was famous right from the start: in 1392, the Prior of Lindisfarne came to buy some cows; and in the fifteenth and sixteenth centuries, the *custos animalum* (animal keeper) and the 'cellarer' (cellar stocker) from Finchale Priory and Durham Priory visited.

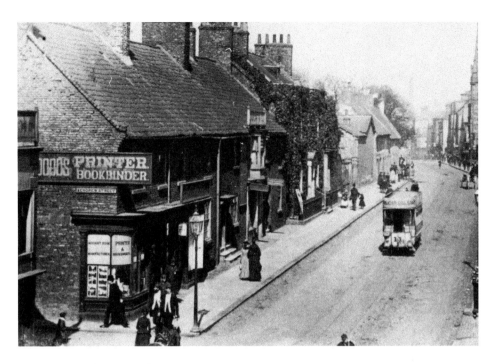

Northgate Looking North

The camera was pointing north from Kendrew Street. Ivy House is in the centre while the Bulmer Stone is outside the cottages at the top left. A No. 11 tram is passing Ivy House, which was home to Darlington Liberal Unionist Association. J. Dodds is the printer and bookbinder on the corner.

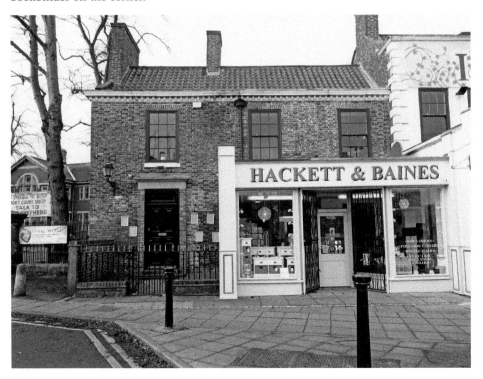

Blackwellgate

Blackwellgate (which formed part of the A1 Great North Road) in the 1910s with the long-gone Fleece Hotel on the left. Binns moved into Jas. Smith's premises on the right-hand corner. Nearby Blands Corner is rich in history: it gets its name from the garage owner operating here during the First World War, previously known as Angel Corner after the pub The Angel, which closed in 1873, was converted into a Sunday school and demolished in 1971. The site was later occupied by Evans Halshaw's car dealership, next to a Second World War pillbox. The animal drinking trough, which was placed outside the school in November 1913 by the Metropolitan Drinking Fountain and Cattle Trough Association, was moved to the opposite side of the road.

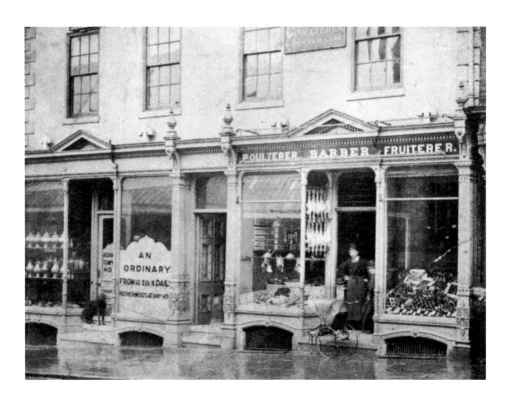

An 'Ordinary'

Horsemarket shops including Adamson's Commercial Hotel offering 'an Ordinary'. An 'Ordinary' was a deal whereby meals were provided at a fixed price. In the nineteenth century the markets became more specialised: High Row became focused on cattle, sheep were sold in Tubwell Row (in 1851, the Queen's Head pub, in Tubwell Row, gave its address as 'the Sheep Market'), geese could be had at Prospect Place and horses were sold in Horsemarket and Bondgate.

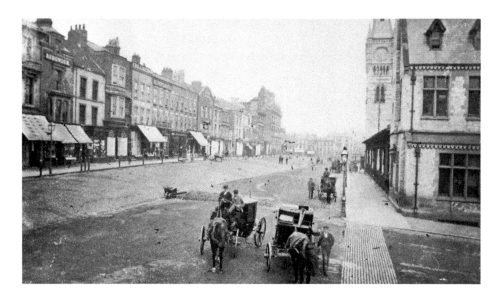

High Row

High Row around 1880 – today the gas lamps, cobbles and iron posts are long gone. The year 1901 saw the construction of the terraced road to replace the slope shown here. Samuel Tuke Richardson, the 1875 satirist, described High Row and Cow Monday in his cartoon book about Darlington: 'The young men and maidens attendant on the beasts also seem to imagine that the High Row is their especial property, and march and strut up and down with an air of great self satisfaction. The nymphs dressed in the most gorgeous colours it is possible to imagine; while the young men blossom forth in resplendent neck ties, generally of a brilliant green, with a scarlet centre, the whole crowned by a paper collar. The more venerable agriculturalist is scarcely more pleasing and their ladies block up the thoroughfare in a most effective manner with their baskets of eggs, butter etc., which they shove in your ribs, or perhaps they drive the long point of a gingham umbrella into your eye whilst their husbands drive hard bargains and tell many lies over a solitary heifer.'

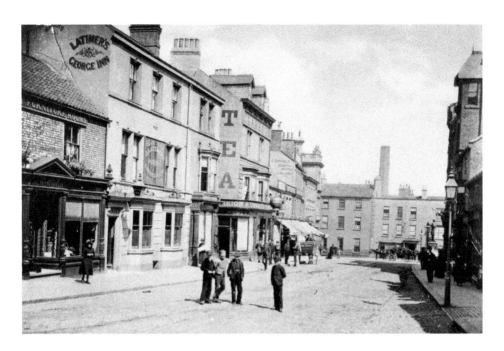

Bondgate and the Bondmen

The top image was taken around 1890 looking towards the King's Head Hotel with Pease's Mill tower in the background. In the Middle Ages most men were villeins or bondmen, half slave and half freemen. Bondmen were tied to the land and had to spend some of their time working on their lord's land. Some of these bondmen lived in Bond Gata. In 1826 an epidemic wiped out most of Darlington's cats, so someone set up a stall selling cats on the market, with prices ranging, depending upon age and beauty, from 8*d* to 18*d*.

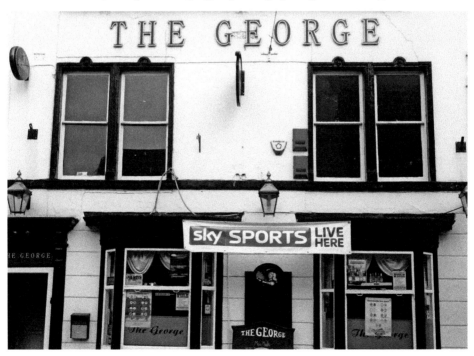

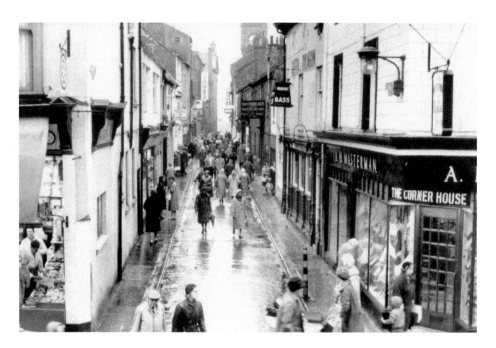

The Green Dragon
The photos show Post House Wynd and The Green Dragon on the right.

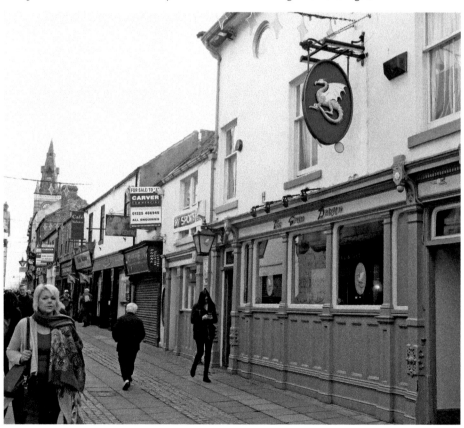

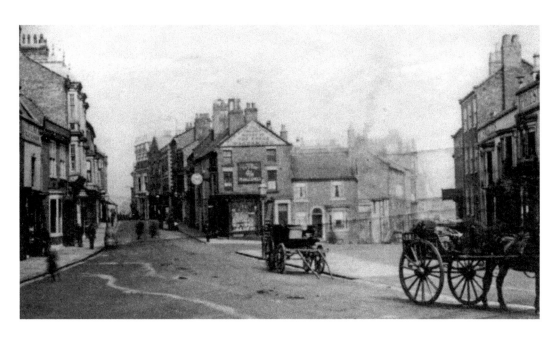

Blackwellgate

The Punchbowl Inn used to stand beside Carmel Road. Like the other pubs in Blackwell parish – the Angel at Bland's Corner and the Nag's Head and Ship Inn – its main trade came from the drivers of coal-carrying ponies on their way from the south Durham pits to Yorkshire markets. The advent of the railways killed this off. The Punchbowl closed in 1899.

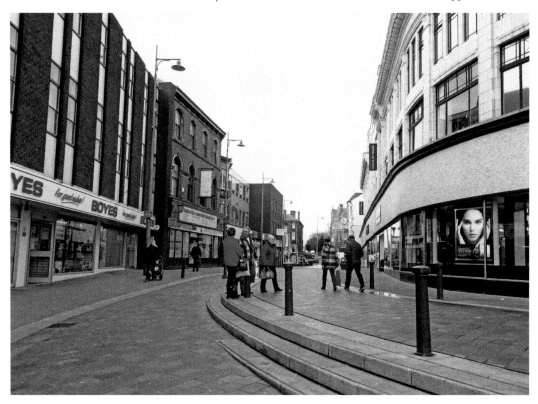

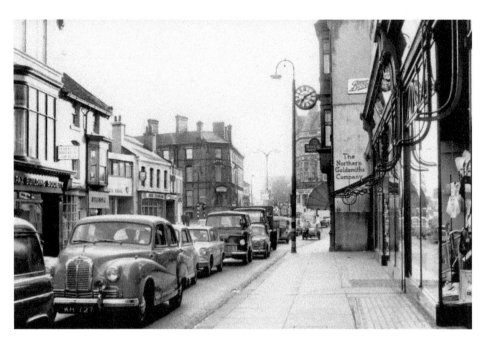

Blackwellgate, 1962
Northern Goldsmiths still trades today, as the new photo shows. This branch opened in 1927 but the firm's first showroom opened in 1778 – the UK's first Rolex watch stockist.

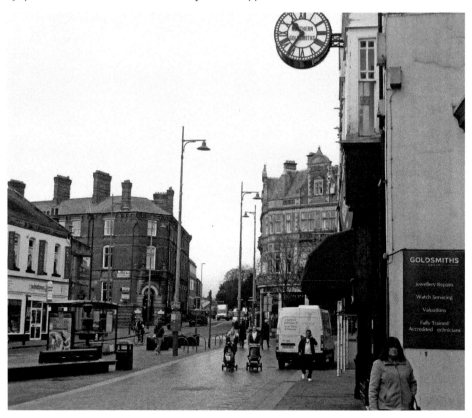

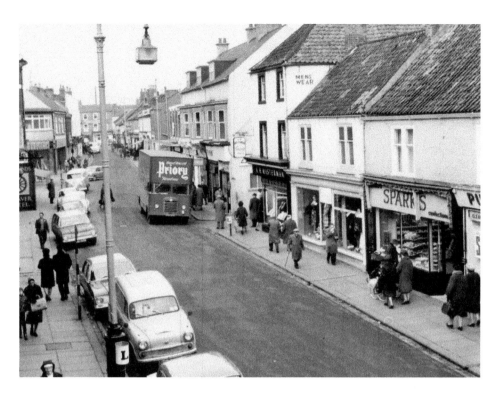

Skinnergate, 1970s

Skinnergate is, of course, indicative of Darlington's leather industry – this is where the skinners lived. Brewers and porter merchants William S. Firth started life producing and selling aerated waters from a well in Skinnergate. They were also famous for their Special Reserve Finest Malt Old Irish Whiskey.

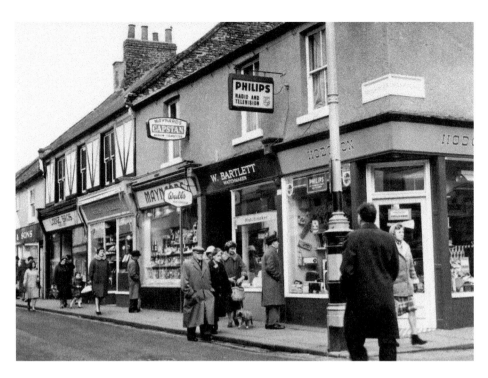

Skinnergate, 1965
The old image shows shoppers on a popular road in 1965.

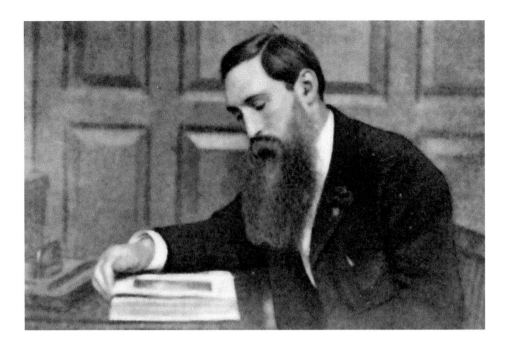

J. M. Dent

The famous (teetotal) publisher J. M. Dent (1849–1926) was born in Darlington in what is now the Britannia public house in Archer Street. In 1888 he founded J. M. Dent and Co. (J. M. Dent & Sons from 1909). Between 1889 and 1894 Dent published Charles Lamb, Oliver Goldsmith, Jane Austen, Chaucer, Tennyson, and many other classic authors. The publication of books in the Everyman Library began in 1906 with 152 titles issued by the end of the first year. Dent died well before publication of his target of 1,000 volumes, which was attained in 1956. The magnificent mural can be seen in the Crown Street Library.

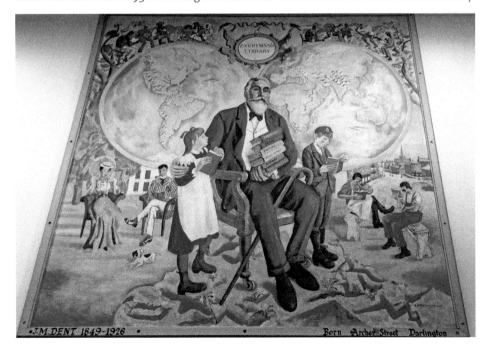

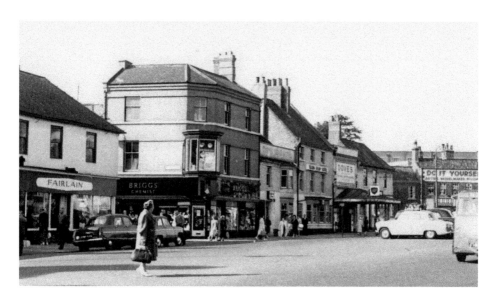

Bondgate and *The Northern Echo*

This famous newspaper started on 1 January 1870 in Peasegate under the editorship of John Hyslop Bell and with the financial support of the Pease family. One of its objectives was to provide a retort to the conservative gushings of *The Darlington & Stockton Times* and *The Darlington Mercury*. The second editor was W. T. Stead, one of the great pioneers of investigative journalism, who brought the paper to international attention with its coverage of the Bulgarian Atrocities in 1876.

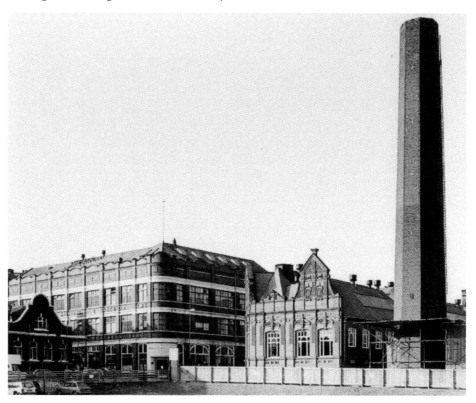

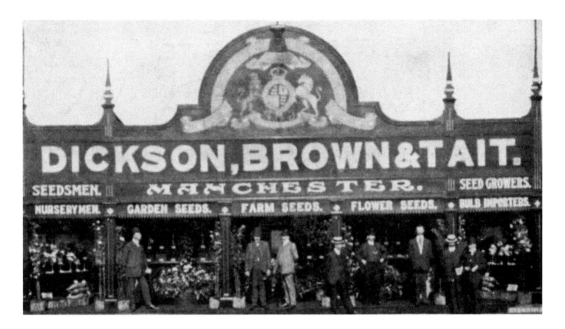

The Royal Agricultural Show of England and North Lodge Park

1920 was the year in which the Royal Agricultural Show of England came to Darlington. Over 133,000 people attended the event, including the Duke of York – later George VI – which took place at Hunden's Farm. The photo shows one of the exhibitors. The lower image shows the splendid North Lodge Park in 1907, with bandstand, fishpond and castellated boathouse once owned by William Backhouse. The pond was routinely topped up with surplus water from the swimming baths in Gladstone Street. It was filled in in 1932. Sadly, the boathouse was demolished in the early 1950s.

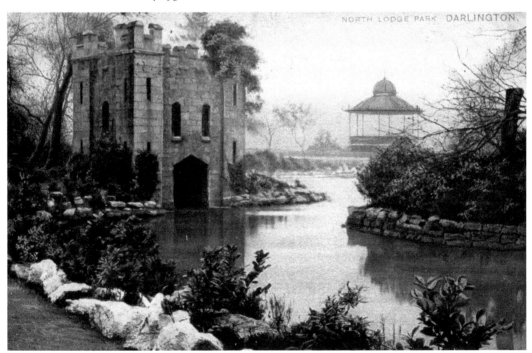

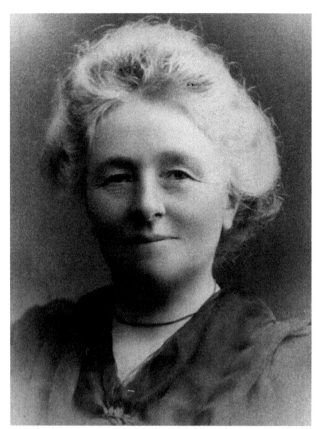

Clara Curtis Lucas

Clara Curtis Lucas was the first woman to be elected as councillor for Darlington County Borough in 1915, when Darlington gained county borough status. She was one of three councillors to represent Cockerton Ward. Lucas was born in Thirsk in 1853, completing her education at Polam School in Darlington. She was a pioneer and avid advocate of women's rights and helped confer the parliamentary franchise on women. When the Darlington Women's Liberal Association was first formed in 1882, she was appointed honorary secretary, a post she held for eleven years. She was also chairman of the Darlington Woman's Suffragist Society and honorary secretary and vice president of the local branch of the BWTA and president of the North Road Women's Temperance Society. Clara Curtis Lucas died in 1919, aged sixty-five.